RECONSTRUCTION QUEST

Praise for *Reconstruction Quest*

"John F. Gerrard is an incredible human and to be so brave as to share his story and teachings from life is a great privilege for the reader. I have worked in mental health and psychosis-risk research for several years and the way that *Reconstruction Quest* encompasse the complexity of mental health experiences and the richness that connection and creativity provide is both informative and expansive to the current literature on such topics. *Reconstruction Quest* is a wonderful read for folks who are looking to learn more about mental health, the complexity of neurodivergence, and authentically shared lived experiences."

— **Dominique Bonneville**, *Child & Family Therapist*

"*Reconstruction Quest* is an invaluable resource, offering profound insights into neurodivergence. Gerrard's exploration of his unique mind provides readers with realistic perspectives on different ways of thinking. Join Gerrard as he navigates life-altering adventures with distinctive characters and influential relationships. Reflect with Gerrard as he bravely and honestly shares his defining moments. Then, ask yourself: cause or effect?"

— **Debbie Wiebe**, *Co-founder, School of Peer Support,*
Canadian Mental Health Association

"*Reconstruction Quest* is a deeply engaging memoir that explores the author's mental health journey with remarkable empathy and courage. Gerrard's narrative is not only well crafted but also incredibly engaging, drawing readers into his experiences the whole way through."

— **Sandra Falconi**, *M.Comm.*

"Community strengthens us, challenges us, and gives us our lived experiences, which become our stories. Gerrard's journey comes alive with hard truths about relationships, connections, and losses, in the midst of the experience of living with mental illness. He offers hope and inspiration while reminding us all to lean on our community supports to find health and to know we are loved."

— **Dena Leigh**, *Primary Educator*

"From a Peer Support lens, I found *Reconstruction Quest* to be a powerful reminder of the value of lived experience and the impact of connection, resiliency, and hope all have on recovery. Gerrard's memoir left me reflecting on the neuro-complexities that we all share. His vulnerability offers a unique perspective on the importance of empathy and community support within mental health."

— **Scott Lockie**, *Peer*

"*Reconstruction Quest* is a memoir like no other. An authentic self-analysis of neurodivergent life that offers practical insights, and an engaging storyline that had me captivated from start to finish."

— **Matthew Swan**, *BA*

"Such a brilliantly paced autobiography, I read it from cover to cover in one sitting! It provides us with not only a fantastic insight into what it is like to experience those sensations which are considered to be outside the norm, but it also equips us with the tools needed to understand and contextualize them too. By reviewing his own personal history, Gerrard encourages us all to give more thought to our actions, reactions, and how those fall into place in the greater scheme of this thing we call life."

— **Stephanie Voaden**, *Peer*

"In *Reconstruction Quest*, Gerrard revisits many key events of his life—moments of such deep agony and pain, loss, and grief, intertwined with beautiful glimmers of pure joy, friendship, belonging, and 90s nostalgia. As a Psychologist, I am so grateful for Gerrard and his courage to provide insight into the experience of altered states. This work is beyond valuable not only to help those who are now where [he] was then, but also for friends, family, loved ones, teachers, and health care providers."

— **Meg Hasek-Watt**, *Registered Psychologist*

RECONSTRUCTION QUEST

A Neurodivergent Journey

John F. Gerrard

Book layout by John F. Gerrard
Cover image: *Conversation*, 2021, painting by John F. Gerrard.

ISBN: 978-1-7780501-3-8 (paperback)
ISBN: 978-1-7780501-4-5 (ebook)

First published 2024

John F. Gerrard Publishing
Calgary, Canada

johnfgerrard.com

for my parents

"Life can only be understood backwards; but it must be lived forwards."

— Søren Kierkegaard

CONTENTS

PART THREE — Reconstructing the Storm

PART FOUR — Reconstructing with a New Peace

Favourable and Unfavourable Divergences (Preface)

When I first got my mental illness diagnosis, it was bittersweet. Part of me felt vindicated, and it was good to have an explanation for what I was going through. But it was also troubling. I was deemed to be mentally *disordered*.

The language we use to describe ourselves matters. People tend to be influenced by what they accept as their identities. Or can feel justified to act a certain way depending on how the stories they accept define them. Our self-talk has a way of shifting how we see ourselves, and how we see ourselves influences who we become.

There *was* significant disorder in my life. I was very sick. It would be foolish to say I wasn't experiencing mental illness. Yes, I had a mental illness, but as a whole, I was more than that. I was neurodivergent, a label which provides space for more than just the negative aspects of abnormal psyches.

Neurodivergence recognizes that some people's brains are different from those with typical neurology and that this isn't necessarily bad. The divergence is typically from the most common or the average—so, the majority. Neurodivergent people are cognitive minorities.

Where this line is drawn is up for debate. Every brain is unique, but some brains are more typical than others. There are specific neurological conditions that are seen in some people but not in the majority, such as autism, dyslexia, ADHD, intellectual disabilities, and bipolar disorder, to name a few.

For myself, creative traits have coincided with or are a part of my bipolar type, and I've observed creativity being coupled with mental illness in many others throughout my life. I've also noticed how a heightened propensity for abstract thinking occurs with certain mental illnesses—which, depending on how it's nurtured, can produce wonderfully positive outcomes, or can facilitate delusional thinking by leading to disturbing scenarios or outlandish beliefs.

There's also the increased emotional sensitivity that I've seen in a lot of people with mental illness. This can be overwhelming and lead to numbing behavior such as self-medicating with drugs and alcohol. However, those same sensitivities can lead to excellent outcomes when the person channels those energies in healthy ways.

I like the term *neurodivergent* because of how broad and neutral it is. Divergence from average brain functioning holds the potential for favourable or unfavourable outcomes, depending on environmental factors as well as on the individual's choices. In my experience, there's often a sensitive nature or heightened receptiveness at the root of these positive and negative outcomes. For me, creativity requires an openness that's aided by being more sensitive to my surroundings. This same openness facilitates and is exploited by my delusional thinking.

I identify as being neurodivergent. Some of my neurodiversity I embrace, and some of it I battle. As much

as I'd like to avoid the suffering I feel from parts of my condition, I understand that losing what facilitates the bad outcomes would mean losing what facilitates the excellent outcomes. Thankfully, I can minimize the negative if I'm supported and do my best to avoid self-destructive behaviour.

When well taken care of, there's great joy in being neurodiverse. I've worked hard and been helped by others to thrive as a neurodivergent. I've also felt the disconnection from being isolated from my community and my better self. Both the negative and the positive have taught me lessons in their own way. The hardships I've experienced have served as positives, not in themselves, but as teaching tools, contrasts, or immediate awfulness that promoted a more ultimate good.

While writing this book, I've been reframing my life and moving my understanding of it closer to the truth, searching for the correct language to capture a *realistic* story for my mental health journey. There have been some truly awful moments, and it's genuinely horrible how mental illness can hijack someone's life. However, I've learned that I can minimize the negative outcomes and maximize the potential positive ones with proper treatment. I may have a mental illness, but that's not all that defines me. In the pages that follow, I share my story with you.

Acknowledgements

Thank you to my partner for her relentless love and encouragement. Thank you to all my friends and family for all the meaningful connections I've been lucky to have made over the years. Thank you to all who support my art and writing, whether by sharing it, or by buying a book, a print, or an original painting.

PART ONE —

Reconstructing the Foundation

Foundational Sponge

It was a great night until the movie showed a monkey dying. I was so disturbed by this that I went to the washroom and stared at the mirror and held my breath until I passed out. I woke up soon after with a big bump on my head, having hit it on the sink on my way down to the floor. Hearing me falling, my parents ran over to me, concerned and confused about what happened. I don't remember explaining it, but I don't think I lied. It was a horrible feeling that I'd felt, and all I knew was that I needed that feeling to stop.

There were many big emotions growing up, some easier to laugh about now than others. I was a few years older, 9, when I bawled uncontrollably at the sight of our lime-green watering can getting destroyed by a particularly aggressive hailstorm. I remember staring out the window as the white pellets came crashing down. It was as if violins were playing solemnly in the background. Very dramatic. I liked that watering can.

I imagine that dealing with these sorts of intense emotions is something we all struggle with to a certain extent. Still, some seem to fit the norms more than others. My early life had some high highs and some low lows, but

the problems I would end up having later in life were more obviously extreme. Before this mental illness, my perceptive and sometimes erratic nature led to challenges at school and other social occasions. I often felt like I was in a movie without the script or saying the wrong thing, too eager or naive. I would later learn to establish better boundaries with antagonistic forces. But at this stage, I'd get embarrassed when I exhibited my potent feelings, the regulating of which was difficult for me.

I'm not to be pitied for being so sensitive, although some may look down on it as being a weakness, something to be ashamed of or to conceal, especially as a man. In many ways, though, I'm grateful to be this way. Because of it, I have experienced many beautiful headspaces and have creative skills I'd unlikely have without it. That being said, it has been challenging too, difficult and sometimes overwhelming. Some feelings have seemed like they would make me burst at the seams. Feelings can feel too big to fit, or we can feel the feeling of missing them when the ones we want aren't there. Feelings help us communicate with each other; they help us survive. Sometimes, we pretend to have feelings we don't have.

At around 9 or 10, I got involved with an organization called Calgary Young People's Theatre. My mom had a background in theatre, and I was excited to join in on the fun. Acting allowed the younger me to immerse myself in different characters and begin exploring various human themes—to try on other traits and attitudes like they were shirts and I was in a changing room at a clothing store.

As an actor, I had flaws, always struggling to remember my lines and act in a way that wasn't over the top. Ironically, you don't want drama to be too dramatic. Although, like with lots of art, I don't think it mattered to me how good the result was. I enjoyed the process.

I'm tempted to see the hyperactiveness and forgetfulness as signs that I had the potential for a mental disorder or that I in fact had a mental disorder. More forgetfulness, problems containing my spirit, and attention issues would later lead me to be diagnosed with ADHD as an adult. Looking back, I wonder if it was a good thing that I wasn't diagnosed as a child. I might have used it to justify bad behaviour. Or I could have been treated with medication that would have changed my trajectory, for better or maybe for worse.

Regardless, I've come to appreciate and be grateful for my timeline. And I understand why my parents might have been reluctant to talk to mental health professionals. Back then, mental health was treated much differently than it is today, and we still have a long way to go. It would have made sense that my parents would have leaned into seeing my problems as being perfectly normal for someone with my personality type.

They had moved from England to Calgary, Alberta, Canada, a few years before my sister and I were born. Both are very clever and accomplished in their own right and were involved with various professions. My dad was in the British Air Force, which helped him get a degree in aeronautical engineering. He did some work in construction and then worked in oil and gas for most of my life. My mom's career path was more diverse and included (among other pursuits) being a police officer, a violinist in an orchestra, a Johnson & Johnson baby shampoo factory worker, a Braille transcriber, a music teacher, pub owner, playwright/actor/director, and Methodist minister. Before all this, she got herself a history degree while away from home at university, where she would sketch the buildings between classes.

I've yet to follow in all these footsteps, but I have pursued creativity as she did. It was in art college that I fell

in love with drawing, though I had dabbled with it in elementary school. I would trace other people's images and make my renditions of the popular anime *Dragon Ball Z*. I strived to be like the heroes I'd draw and pretended to be like them, leapt around my house in costumes as if I were the protagonist I wanted to be. Creativity would later become a massive part of my identity and has served as therapy, a way to express myself, and a professional pursuit. I'd go on to make images and music and play with the written word as I am doing in this book.

Some of my favourite times growing up were going to the library with my mom and sister, who is two years older than me. We'd go to the gorgeous pyramid-shaped one in south Calgary and take home as many publications as we were years of age. Along with books, I loved comics; I also had a fascination with everything medieval, taking in picture books about archaic weapons and practices. World War II and other wars were also interesting, leading to staged battles using foam-dart guns and homemade elastic-band guns made from wood chunks that I carved out of two-by-fours in my dad's workshop. I loved working with my hands and spending time there. One tool I remember was a 50-year-old hand drill, where you had to turn a crank to make the drill bit spin. Some objects are so much heavier than their physical weight, aren't they? That drill, with its oranges and blues, reminds me of my dad. I don't really have the words for it but, oh, what a gateway that drill is when I see it in his workshop, to a time that now feels like lifetimes away.

On other now-ancient devices, portable cassette tape players, I'd listen to 90s hip-hop, pretending to be more tough and fearless than I was. Music of all types, though, would eventually enter my life. From sentimental

and dramatic pop to death metal. Music has been a great source of contentment for me. It's provided and continues to provide a space for big emotions. Playing it came into the frame around grade 6. I would pick up my mother's acoustic guitar and fiddle around on our piano, interests that were fostered by my parents, who got me music lessons at the local music store. For the most part, though, I taught myself as I was often too stubborn to follow a structure or listen to a teacher, with this and other activities. I began to dream of being a musician, which was far more attainable than being Spider-Man, though it would require plenty of hours of practice for me to reach that goal.

Many of my other favourite activities growing up were solitary, playing Lego, or learning something from a book when I had the attention to do so. I was lucky to have some good friends, but I always felt in some way an alien. Sometimes, it was like I belonged, but not as an equal. Woe is and isn't me, as those social trials we all seem to face to some degree were tempered by the strong foundation I had to rely on at home. I had great times with my family. We hiked in the mountains and set up camp beside firepits. Sitting by a fire remains one of my favourite ways to relax. There's something therapeutic about watching the flames flicker around. So random. How could you ever predict where they'll flicker next? Fire is the freest, except it relies on having some fuel to burn. Fire makes the most extraordinary sounds, so analog and crisp. I'd often focus on the flames, lost in thought like I was on another planet.

Focusing in other ways became hard as elementary school progressed. I became a poor student because of it. This would leave me feeling stupid at times. But, perhaps I was a fish being tested on how they'd climb a tree. I had the greatest respect for learning and had great intentions to do

so, but when it came down to actually doing it, my ideals were mismatched with the reality of my attention span. Reading on my own wasn't as tricky, maybe because I had chosen the subject matter, but eventually self-directed reading would become difficult too. This was frustrating. Being too bored to concentrate at school, coupled with what felt like constant misplacing or losing of my possessions, now seem like obvious signs of ADHD. Would it have been better to have gotten help earlier? Maybe, but it's hard to say where that would have led me. I try to be compassionate with myself and others by realizing that we didn't know back then what we know now, so it doesn't make sense to judge yesterday's decisions as if we had today's information while making them.

Although I struggled with it at school, my curiosity found its way to learn in other ways, becoming engulfed in great movies, AM radio, and TV shows. Some radio shows were recordings from the 1940s and 1950s, exciting mysteries and trope-ridden comedies. There was also *Coast to Coast AM*, which featured interviews with conspiracy theorists and with people who claimed to have seen aliens. I'd wonder how accurate the alien stories were and listen to these shows late into the night, in a bed by the window, where I could see the moon and stars. I've always been fascinated with the night sky and skies in general. I love how the stars seem so foreign and ours simultaneously. They sparked a sense of wonder and awe and oozed possibility. I wondered what was out there. Aliens? Starships? As I got older, I quickly became obsessed with *Star Trek*, with its moral dilemmas and scenarios, depicting all sorts of cultures foreign to humanity or sometimes exaggerated parts of us. Tales of choosing lesser suffering to avoid a greater one, exploring

possible fiction using science as we know it. The storytelling complemented the ethics I was learning at home through my family and elsewhere. It was wonderful.

After the social chaos of school, I'd come home and put *Star Trek* on. It was part of what made my home a sanctuary, and I was fortunate to have lovely times there. Alone with the television or talking and laughing with my family at some dumb joke or mishap. I had a privileged childhood in many ways, with the stability that promotes healthy growth. I had supportive parents, whose love I never doubted. As positively formative as this was, the reality was that there were also chaotic interactions with the world that I had to reckon with. These toxic interactions happen to everyone to varying degrees. Some have better luck than others. A severe incident may be less severe when felt by a less sensitive person and an apparently less severe incident may be more severe when felt by a highly sensitive person.

There was the agony I would feel in grade 6 when I got sick with appendicitis, the pain that led to a pretty serious altered state. I lay in bed, believing there were aliens and an elaborate puzzle to solve; this was arguably my first madness. A sign I was vulnerable to psychosis, if not psychosis itself. I didn't express the extent of my mental derailing, so my family was unaware of it. Luckily, my psyche returned to home base when my physicality was healed, so I didn't need the help they could have given if they had been aware of my troubles. I felt an awful fear in this brief insanity and then in being in the hospital and having surgery. I also witnessed someone else's pain, which cut especially deep due to factors which should be obvious by now. A boy I shared my room with had his spine straightened out, and he screamed at them to stop while they carried out the procedure.

School had its own troubles, a place which for me and unfortunately many others where there was a lot of verbal violence to reckon with. I grew up in a time when the words *gay* and *fag* were go-to insults for anything undesired. That never sat well with me, and this attitude itself was deemed to be gay. And then there was my first French kiss, where we sat in a circle and spun a bottle. Whoever the bottle "chose" would then put their faces together. I was nervous about this, so I naively asked my friend in private how to do it. To my horror, the next day at school what I said had spread to what felt like everyone, and many ridiculed me for asking the question. It tainted what was such a wonderful moment. Social chaos. Social pain. Early life has its challenges for all of us. We all struggle to find our way. But that doesn't make it any less hurtful when there's rejection. I know we were doing our best to grow up and fit in, which is not an easy job or hobby for anyone but, man—kids can be so cruel, and it's even more hurtful when you think they're your friends. The first year of junior high wasn't very pleasant. I played basketball, but my coordination wasn't great, which led to what felt like an unsavoury nickname—Cletus the Slack-Jawed Yokel, an idiotic and inbred character from *The Simpsons*. This would soon devolve (evolve?) to being called Clitoris. This was hurtful, although, in retrospect, being called a pleasure centre for women could be seen as very flattering.

I can laugh about these things now, but at the time they were devastating. Fitting in is so important for kids (adults too, for that matter). We're social creatures, and when we belong, it does wonders for our mental health. On the flip side, when it doesn't work out, it can have adverse effects, and I was starting to experience those

effects in the form of anxiety and depression. After that gauntlet of a first year of junior high, life was still just getting started. In the second year, I would make some new friends. I was inching closer to adulthood, and I'd soon have my first drink, my first smoke. This was fun but would turn out to be harmful to me. I didn't expect the consequences that followed those choices, but it can be hard to predict what will happen from our beginnings, can't it?

An Incomplete Peace

We were in the forest with a pop/soda can formed into a bowl-like structure, with holes poked in it so that smoke could travel through. A green and brown sticky substance shaped like a clump (recently pulled from a Ziploc bag) was placed on top of the pop can bowl. I was 14 or 15, and a couple of friends of mine had taken me to a secluded area so I could get high for the first time. I was curious about it. I remember being so excited and also nervous, the sort of butterflies you get when you know you're about to do something that could be wrong.

I didn't know how wrong this would be, and in truth, I still don't know definitively the scale at which this early drug use affected me. Sometimes, immediate pleasure can lead to great suffering in the future, and this may be the reality. It's hard to know what's despite and what's because in life. Still, if cannabis didn't help activate my future mental breakdowns, it did other negative things, like serve as a sort of crutch later in my life that I used for many years, distracting me from obtaining more sustainable non-drug highs. But you could reframe that and say that it helped me cope, too. I have to be honest. Cannabis has provided me with many good times. It just wasn't harmless fun, I

suppose. What's done is done, though, and I think it's OK to recognize that there were positive aspects to my drug use. That doesn't mean that doing it was the right choice.

This was the first time I had smoked *anything* before, as I smoked weed before cigarettes. I was eager to try, so Dave passed me the bowl. I didn't have to light it because it was "cherried," as is said. The clump of cannabis had transformed into a burning ember, red like a cherry. I pulled the air from above the makeshift pipe through the cannabis, which then glowed—the smoke itself was a dark grey and made its way into my lungs. It didn't take long before I felt the effects, which are hard to describe. The first word that comes to mind is *peace.* I felt a certain peace that I had never felt before. Things were lighter and funnier, and I was content.

So many great times in this period. I feel like I both do and don't regret the substance abuse that would accompany it, which is a wild thing to say, considering the damage it likely caused. Looking back with the benefit of hindsight, it's easy to say this, attributing today's information to yesterday's decisions. Now that I'm here, I'll be honest: I'm reluctant to admit that I made a wrong choice with it. Perhaps it's even harder to admit we're wrong when we make the same decisions repeatedly. The truth is that a lot of this was terrific and relieving in an immediate sense. Still, it would cause damage to some of us, ultimately. It felt like a solution to my problems, but it wasn't. I would go on to face some serious mental health struggles, and Dave passed away from mental health reasons. All things considered, I don't think I would smoke weed as a teenager again.

Some studies show that cannabis use in youth puts you at risk for psychosis.[1] It may not happen to you, but there *is* that risk. Was it not mental health issues and/or mistreated neurodivergence that led to the drug use, and

then the drug use contributed to more serious mental health issues? Regardless of who wins and loses the blame game, I've found different ways to have fun and with safer odds. An important thing I learned is that I can *healthily* achieve the same enjoyment. Much *more fun than* I could ever have with it, for that matter. For me, weed was what I'd call a cheap option, a Band-Aid fix. Weed may feel like good medicine, but the side effects, for me, outweigh the benefits. It's different for some other people. Their identity includes enjoying cannabis, which works perfectly fine for them and is not so toxic, and is arguably less harmful to the body than alcohol use.

It's so strange how one thing can be medicinal for one person but toxic for another. It's like how the same song that makes one person depressed can inspire someone else. The fact that the same treatment can produce such different results is one of the most challenging problems we face in giving someone mental health care. That, and getting someone to accept help in the first place, a reality that can be particularly frustrating for families.

Some of the damage of this phase was in the form of how it affected my parents. They did their best to reel me in, but I drifted away. As I began high school, my grades suffered more and more, and I struggled to find my footing socially. My friend group was fun, but I often felt out of place. My mild depression was becoming moderate, and I thought weed and alcohol were perfectly acceptable treatments. Some sort of other treatment, like therapy, might have been helpful, but I kept many of my problems secret. My parents were aware of some of them, but I've always hidden things pretty well, able to maintain that smile on my face as a mask. Still, conflict began to happen more frequently, and most of it was with my dad.

Middle Ground

There we stood together. I, a rebellious high school kid, was face to face with my dad. I was frustrated with the curfew he wanted me to adhere to, and he was frustrated with the decisions I'd been making and thought I was on the wrong track. At this age, we were worlds apart. It was like we were speaking different languages. My father is a force to be reckoned with. Physically quite intimidating at six-foot-six, he has a way about him that is calm, strong, and assertive, though at this moment in time, I was testing his patience.

I may be biased, but I've come to think of my dad as a champion of man. Waking up at 6 o'clock five days a week to feed the family. Smart as all hell with a great sense of humour. He's faced some serious challenges and overcome them well. At this moment, though, our argument was indicative of the rough patch we were in, both gradually raising our voices and struggling to express the big emotions that we were feeling. He threatened to kick me out of the house, which made me smirk—I knew he was bluffing. That smirk made things a lot worse, which I should have known wasn't a good thing, though at that moment I didn't care about the pain I was causing. I was reckless and hard to control. A handful.

Along with the substance use I've mentioned, I was big into counterculture, reading political essays and other writers critical of capitalism and popular culture. I felt like I had all the answers already, which is strange because I've been learning more and more ever since. Teenagers will rebel, I suppose, and there's philosophy from this stage of mine I still believe in. But there was a certain hypocrisy in me "writing my scathing review" of him and the greater society, which was facilitated by the "pen" he had bought. We faced different challenges and had very different *values* at that stage, as is common between different age demographics and parent and child. Still, I'll admit I was hypocritical. Standing there, my father's signature composure returned, and he told me that we'd talk about this more later. I nodded and went to my room, where I'd spend the next few days mostly asleep. Looking back at this now, I regret how inconsiderate, how stubborn I was back then. But as much as I can empathize with my dad now, I don't want to look at the past as if I had today's knowledge when I was making those decisions. I did the best I could back then, and so did my dad.

Having a kid so different from you must be really hard. I, the creative and at times chaotic type, which, compared to his immaculate organization skills, was bound to cause some stress. My dad could be hurtful, with his very logical and matter-of-fact way of being, paired against my sensitive nature. Some things that were easy for him were hard for me, and vice versa. This was frustrating because it was hard for one person to understand why the other person couldn't simply be like them. When we're frustrated, we can lash out, and part of the vulnerability of close relationships is that we often know where our hits are hardest, where they hurt the most. It can become tough to forgive certain things,

although that's what needs to be done to lighten the load of our anger. It has taken years, but from where I write now we've been able to work through our difficulties. It required effort and change on both our parts. As we grew, we both got better at relating to each other. Also, as my mental health improved, conflict in general decreased. We've learned to accept each other for who the other person is. We stopped trying to change each other. We learned to listen better and respect that the other person was *human*, too. We're different, but we're also very similar. Both stubborn in many ways. We had to overcome that by making space for each other.

A certain amount of forgiveness and growth was necessary for us to find the middle ground, and finding a middle ground is important in many areas of life and has been something I've struggled with—as in the case of my dad and me, and with other people with perspectives and values different from mine. Among many other middle grounds, there's the balance between doing without and indulging, between your professional and personal lives. There's having the right balance between being unsustainably happy and one of the most common mental health conditions: depression.

From this view, I was likely struggling with some depression during this time that went beyond the normal teenage moodiness, depression that was fueled by the conflicts I was having at school. This, coupled with the signs of ADHD, made it difficult to do things I needed to do, like schoolwork and helping out around the house. My dad's view was that I was being ungrateful or self-centred and that I should have been able to "pull myself up by my bootstraps." Maybe that's an unfair characterization. Maybe he was simply concerned and didn't know what to do, or

perhaps a complicated mix of the two. Regardless, I was making bad decisions, albeit decisions which were greatly influenced by the discomfort I felt just *being me*. I felt like an alien in many social situations and began to see myself as being set apart in a bad way. And then I felt justified in isolating myself further.

Uninvested

There I was in my room, avoiding my parents, avoiding *life* really. What little light there was poked through the gaps in the blinds. The sun shone through and made beams of mundane dust. Standing there, I looked at the defeated person in the mirror. I had slept all Friday night and now late into the afternoon Saturday.

Teenagers tend to sleep more when they can, but there were other symptoms of depression I was keeping to myself. I lacked the motivation to do what I'd usually enjoy. Smiles were fake. I had no energy and had a hard time concentrating. I felt worthless. The three words that suited me best were *I don't care*. However, looking back, I think I cared more than I let on. The care I did have caused me to suffer because I felt like I was failing in the areas I cared about. Socially, it felt like I was drowning.

What a horrible pit I found myself in. Tears would have been a welcome release, something to shed. I just felt empty and a burden, a burden no matter which way I looked at it. If I stayed alive, I'd be a drain. If I died, I'd be even more of one. As I looked at myself in the mirror, I saw someone who was unworthy. If life is a gift, that gift felt like an imposition then.

I didn't want the power to make choices, the burden of directing myself somewhere. I hadn't chosen to live; I would have had to be alive to do so. But now that I was here, I couldn't leave—that's not a neutralizing move. I felt like a worthless character in a worthless story. *Wouldn't it be better if I wasn't here?* No. That would cause a lot of pain. My parents might get frustrated with me sometimes, but they did so because they loved me. How they loved someone so pathetic was shocking to me, although I suppose they were looking at me from a different perspective. I didn't see myself as having any sort of purpose. I wasn't motivated by something larger than myself. I was undedicated, though, and looking through an unrealistic or skewed lens in which I saw myself and the world as being more negative than they are.

I used to get so much enjoyment out of playing guitar, but now it felt dull and empty. When I smiled, I used to really mean those smiles. Now, although there were reasons to smile, I had to fake all my signals of enjoyment. The sky's majesty remained, but I saw it as *just* the sky, without the hope and the magic. The number of stars was overwhelming: they shouted nothingness. It was all so empty, a picture of pessimism. That pessimism might have been somewhat justified, but ignoring the positive aspects of life was like a lie of omission. I was like that with myself, embodying an unrealistic narrative or role because of the alternate angles I was ignoring. My perception was skewed. I was assessing situations and making toxic value judgments, which led me to treat myself in a way contrary to the compassion I was willing to give others.

I know now that if I were kinder to myself, I'd also be kinder to others, as others cared about me. Life was great in that way. I had people who cared about me. I was facing adversity at school, but there was a lot I *should* have been

grateful for. This makes the depression feel like it's my fault. That I am a fool for not being able to appreciate this activity or circumstance. There is goodness in my life, but I am not grateful. I am burdened, and then further burdened with the guilt of not being grateful. My family is so wonderful; I have so much. How unwise I feel I am. If I could only get rid of that heavy weight which is blocking my gratitude.

This depression of mine is cumbersome and slow. Sleep has become a welcome escape, something to look forward to, to be unconscious. I want to be motivated, but I'm just not. I think I could be doing better, so I beat myself up for not making it happen. I crave disconnection. I suppose it's the disconnection that I deserve because I feel like I could have avoided it. I'm haunted by the idea that I'm a master of my destiny, that if I were simply more positive, more positivity would move toward me. This supposed failure makes me feel like it's my fault that I'm miserable. It's my fault that I don't *care*. I should be able to choose my way out of this, but every move I make is heavy and hard. I haven't tried everything, though. Maybe there's an answer out there. Right now, I am doubtful.

When I'm depressed, I want treatment with some formula and for its usefulness to be proven before I instigate any actions. I want to solve it in my mind before doing any of the body work. I always want a knockout punch, some speakable all-encompassing solution found in conversation, rather than pounding away at the problem, hit by hit. I want the motivation to act before acting. However, perhaps paradoxically, the motivation to do the activity would come from doing the activity! I may not be able to change my mind, but maybe if I change what my body is doing, *that* would change my mind.

I could have asked my parents if we could see a doctor. Perhaps medication would help kick-start some motivation. Maybe, but I didn't want to be someone who takes meds. I wanted to be normal.

I already felt set apart, though, and in a bad way. I also felt like I didn't deserve to be well. Though I might not think I was worth improving now, maybe I just needed the faith that I would eventually believe that I was worth it. What do I have to lose? I can start with something little ... maybe.

I needed to get better at finding those small openings and opportunities to reinforce habits that could move me further toward wellness. I didn't always care enough, but I had to do what I could. I needed faith that I was worth putting effort into and that I shouldn't be ashamed of being sick. My effort might be uncomfortable, but it wasn't impossible. Maybe I needed a purpose to endure the discomfort. But how could I find meaning when there was so much awfulness, where awful things happened that were undeserved? Apathy seemed like an understandable reaction to a world like ours. Still, it's *also* understandable to be hopeful despite the absurdity of it all, to defiantly persevere. I needed to believe that.

And so soon, I'd have these battles, with little leaps of faith, where I'd shift the narrative and convince my body to heal my mind. I'd reconstruct. Yes, I might have missed options before, but I did my best with what I knew then. Here I am *now*, at a place to stage those small rebellions, to inch my way upwards. I can feel the fight in me growing. I still feel purposeless, or maybe there are purposes I have that I'm not aware of, purposes I've yet to create or discover.

My mom told me about this youth group and thought I should attend. Sounded kind of lame. I'm *not* a churchgoer, but I decided to go anyway. Maybe it was time to be more open with who I think I am.

PART TWO —

Reconstructing Peace

New Groups

I entered the church and saw people sitting in a circle playing a game. They all looked in my direction, which was intimidating, but someone ran to get another chair, and they were all quick to include me. This inclusive attitude was a welcome change from my first year of high school, which wasn't going very well. I was struggling with my grades and having a hard time fitting in. This church visit was going better than I thought it would. I expected the night to be cringey, stale, and boring—and not to return—but I would soon meet someone who would make a big difference in my life: Antonio.

There were musicians here! After most people left, this tall young man with scruffy curly hair named Antonio pulled out a guitar and a notebook. We sat close as he sang a song he'd written to those of us who were still there. It was one of the first performances of this sort I would witness, and I was immediately drawn to this new character I'd met. After we shared some more music and got to know each other a little, Antonio offered to drive me home. He then told me a story of when he and his friend Jacob were at a camp put on by the church. They led extension cords out

to the forest to watch *Bambi* in the middle of the night. Wholesome. I enjoyed getting to know Antonio and would return to the youth group the following week.

Slowly but surely, my mood was improving, and I was starting to feel less depressed. I felt a new sense of purpose with these people and that I'd like to be a peer to these characters. They represented a direction I wouldn't mind moving towards. After weeks of attending the youth group, Antonio asked me if I wanted to go to a local music show with him on Halloween. I was excited that he had invited me to do this, so I said yes. That Friday night, Antonio picked me up to go to a place called the Multicultural Centre. He was driving his family's black Dodge Neon to take us there. We arrived at around 7 o'clock, right before the bands started playing. The show turned out to be fantastic. It was a cover show, which meant each band picked songs by other bands to play, like Blink 182 or the Ramones. Many people dressed up and it was a great atmosphere. A few other friends from Oak Park attended, and everything had a fantastic energy and liveliness. Many people there, I think it's safe to say, were neurodiverse. It was great to be around them.

We left around 11 and ended up making a stop before we got home. Pulling carefully over the curb in a neighbourhood by my house, Antonio drove through a soccer field with the car lights off, guided by the moon's light. We drove slowly and carefully on the grass till we saw a big dirt hill. We got out of the car and climbed that hill, slid down a few times, and then spent a few minutes looking at the sky. It was its usual mystery, tonight with the moon half-covered by clouds. Sitting there, we held a privileged view together, far from our and others' suffering; we were a couple of kids covered in dirt, taking in a scene that flattered life.

I wanted to take a picture, but we didn't have a camera. I don't think it would've been a good photo, anyway. A picture of the moon rarely does justice to the real thing. Maybe it is similar to how words are always reductive, especially when faced with relaying the magic of a summer night. We left the field and pulled up to my house. I thanked Antonio for everything, went to bed, and lay there with a big smile, feeling grateful.

That show marked a new beginning in my life, where my environment and people made me feel validated. My friends from high school were kind in their own right, although I often felt like an outsider. It wasn't as good of a fit as this new community was turning out to be. I was starting to explore Christianity, which offered the possibility of its own sort of peace. I didn't agree with some of the church's philosophies; I found some of them annoying and backward. I decided to take what I liked and leave all the rest. I would come to learn that a lot of modern Christianity was all about having a personal relationship with Jesus and did its best not to be a religion. Instead, it was meant to be spirituality. In retrospect, I realize now this might have just been clever marketing. However, that doesn't change the fact that I was fascinated with the idea of there being a bridge between an existing God and humanity. Our earthly plain perhaps connected through that hybrid character, Christ, to the magnificent sky and beyond, reaching horizontally and vertically into infinity. That's one dreamy way to look at it.

There are things in life that seem to obstruct this "good view." We would debate things like the problem of suffering and the problem of evil, which is something I appreciated— that openness to questioning and dialogue. Things could get heated, but in general there was respect for people's differences in beliefs, people whom I was becoming close to.

There was Antonio's friend, Jacob, with whom I would soon strike up a lifelong and loving friendship. Jacob's sister Julia would soon be attending shows, too, among way too many other names to mention. It was great to see so many people getting involved. I was finding fellow travellers with whom I could thrive. Things were starting to go well. I quit drinking and smoking weed, feeling convicted and encouraged by the positive peer pressure of my new belonging. I was having a great time sober, and I had a hunch it wasn't good to try and escape life like I had been. The local music culture wasn't always as wholesome, but it mostly had a similar sort of accepting energy. The Multicultural Centre shows have become almost mythological to me, and the church would prove to be a significant place to foster great positivity in my odyssey, my journey to grow up and thrive and not just survive. Or, rather, to be motivated enough to do so. The sky had lost its charm for a while. That is to say, until I was with Antonio on that field, I'd lost the perception that saw it as such. But now I was again open to its potential, captivated by its mysterious canvas, which continued to showcase its spectrum of scenes.

Dealer, I'm All In!

Neurodivergent people—well, *all* people—thrive in a community. Mental illness grows when there's a lack of it, a lack of *connection*. At this point in my life, I still had issues but was happy because I had a purpose with a new band I'd started and was gaining acceptance with like-minded peers. I may have enjoyed this belonging even more so due to the social clashes that preceded it. The contrast made the impact of my new friend group even stronger for me. Now more invested in life, I cared more because I was occupying space as my true self and was benefiting from it. There was great freedom in this, in having the space to be authentic. Perhaps ironic freedom, in that by being connected to others, I was both held down by the fact that I had something to lose and afforded the ability to fly higher. I had escaped what, for me, was the toxic environment of regular school and was starting to experience the opposite of being an outcast. I was becoming popular. Nice!

Attending school online at Rocky View Virtual School, I'd go there for grades 11 and 12. I did what I needed to do to pass, but no more, often taking tests without studying, but scraping by due to (what may be conceited to say)

intelligence that was strong without practice. I did this a lot during my school career, which I regret now because I know I was capable of much more. With this scholarly style, my schoolwork only took a couple of hours of the day, so I had lots of time to practice guitar and do design work that I was starting to do for bands, things like T-shirt designs, websites, album art, etc. I also had a job at a skate shop that Jacob, my now best friend, got me. I was starting to attract interest from girls, which was a welcome surprise. Things were fun.

The road trips were *especially*. We drove to a show in Edmonton, usually around a three-hour trip from Calgary. I was around 16 or 17 at this point. Jacob was a couple of years older and was driving us there. The roads were clear as we travelled, but it was winter and cold. Unfortunately, the car we were in had broken heat vents, all except for one. It was OK, though, because we had constructed a cardboard tunnel system from that vent to the windshield for defrosting purposes. It had its quirks, as we all do, but man, the '86 Oldsmobile Cutlass Ciera—what a vessel. I would spend many a day and night with my friends in that car. We discussed everything or anything we wanted to, with Tim Hortons double-doubles in one hand, making gestures or guiding the steering wheel with another. We even tried a quad once: four sugars and four creams. I wouldn't recommend it. Amidst these indulgences, I began playing with ideas, offering my insights to the group. Words that previously might have been disregarded as "gay" or too emotional were welcomed and encouraged in this space we'd created with each other. I was known to be "head in the clouds" and spacey, and so my friends would occasionally call me absent-minded Gerrard for misplacing so many things and being forgetful. I didn't mind. It was all in good fun. It wasn't condescending.

We were uncomfortable at times, but this was tempered by our camaraderie. Once, we spent a winter night in the car because it had broken down, and we couldn't get a tow truck till morning. The cold was a minor problem, we thought. Jacob had a flare aboard, and I lit it in the back seat, so the car filled with smoke, forcing our exit. The flare was fun, but we were disappointed when it didn't do much to warm us. Not to worry, we had our senses of humour to help pass the time since we were too uncomfortable to sleep. In the morning, we would huddle around the heating vents at a nearby fast-food restaurant. A miserable situation was made less miserable in that we were sharing an adventure.

The Cutlass wasn't the quickest car and it was horrible on gas. We were driving fast to Edmonton, but it would have been an even faster trip if it hadn't been for being pulled over and getting a $200 speeding ticket, a slight blow to our morale. We arrived at the show to see the bands playing in a halfpipe. Cool. Guitarists would soon be running back and forth in it, up one side of the pipe wall and then up the other, sometimes sliding down while they lifted their instruments into the air.

The singer of the band we were going to see, Justin Zemrika, was a legend, and we were all pretty star-struck around him. He was super kind and humble, though, and made us feel welcome. He even paid for our speeding ticket. Justin wasn't a singer so much as he was a screamer, pacing back and forth, enacting fantastic jumps where he'd touch the tips of his toes. Having one hand behind his back was also pretty signature, and every once in a while, you were graced with the classic chin-up Zemrika smile.

There were a lot of beautiful people there, and that was intriguing. Many sported big, backcombed hair dyed black and wore studded belts paired with camouflage bandanas

sticking out of their back pockets. I swore I saw one girl look at me with a flirty smile. Exciting! The smiling girl, the music, the other "weirdo" people. What a night! It was in between bands, and I was sitting by myself on a hill close to the venue. I remember being more content than I'd ever been. I was thriving. I had gotten pretty good at guitar, and our band was putting in the time to get better. It looked like we'd play with Justin's band, Red Echoes, someday.

I saw myself as valuable. And so it felt suitable that I make choices as someone who was. This new identity I embraced became the one I moved towards. Who was I outside my view of myself? Was I really a good person? I'm too biased to answer that. Being outside of myself would require me not to be myself. It would need a God's Eye View to know that answer. And this is part of the vulnerability of life. Whoever I was, I was happy. I tilted my head upwards and felt a whimsical energy. With my head raised, the scene was so large and all-encompassing. The sky felt glorious and enormous, hosting for me its many awesome stars. I smiled to myself, thinking that although I had been hesitant about life for a number of years, now I was all in.

The Place Is Not the Home

Privileged again, I was graced with appreciating another big open sky, complete with an array of distant suns, pinholes with far and burning light. Our wheels clung to the road as we followed its winding course during our nearly 24-hour journey to Toronto. Others were sleeping, but I was awake, staring upwards again, out from and into the universe, this time on my 18th birthday. I'd recently learned that my parents were getting divorced, which was a shock that left me questioning what I knew about their relationship. Still, they handled it all so civilly and the negative impact was surprisingly minimal. Plus, being out and about with my friends served as a great comfort and distraction from the big shift in my family home. The Cutlass was parked in Calgary and we were in another sacred travelling vessel, one we had named Gunther. It would serve as our wandering house for a month, bringing us to see new faces, town by town and city by city.

It's fun to live without a traditional house for a while, and travelling across the country with your best friends is an excellent way to do it. We were out on the road, taking in the sights, not yet afflicted with the burdens

of adulthood—death and lost love. With his head out the window, Avery, our band's vocalist, screamed into the open air, "Glorious, this place is glorious!" Like the rest of us, he hadn't slept much and was feeling the euphoria of newness coupled with fatigue. Avery was one of the most loyal people I'd ever met and another cherished friend. He was also a great leader in the community. He could be fun and silly, but he was also tough as hell and a guy I was lucky to have in my corner. I continued to look out the window and smiled as Avery made himself known with his declaration. There was a great comfort in staring out into the night as the scene constantly changed, with Gunther the van keeping us barrelling along.

Gunther had done quite a few kilometres before we got it but was in pretty good shape for its age. We decided to paint him rust orange. We did a decent job, but it was still pretty patchy. The passenger seat in the front had a swivel chair, so if you wanted to talk to someone in the back, you could do so by spinning the chair around. We rigged up the horn to a button in the back of the van so the person sitting there could honk as he pleased. There wasn't a good reason to do this other than novelty. Lacking control in this way was sometimes annoying to the driver, but Avery took a particular interest in pushing it regardless. Other modifications included a custom sunroof where we cut a hole in the roof and did our best to get a good seal between the van and the sunroof we got from Pick Your Part, a place where they had cars and vans you could rummage through and take what you wanted for a reasonable fee.

This DIY sunroof would prove to be a bad idea, as we were in Winnipeg, and it rained. The damn thing leaked, soaking the people sleeping in the van and almost ruining the video game console we had hooked up to the cigarette

lighter. Mind you, the waterfall effect was nice. We made that van our own. It was a canvas of sorts that we put our choices into. Another object, like the hand drill, that if I were to see now, would transport me back in time, to memories whose origins are now far, far away. A portal, with its various pieces of metal and moulded plastic that became sacred to me.

We ran out of gas in the middle of the night and there were no open gas stations. Not to worry, we had a siphoning kit, a tube we put in our gas tank and then into another vehicle. It was my job to stand watch. This was a "tingling feeling in my stomach" moment to warn me that I *might* be doing something wrong. (I was.) We justified it by only choosing cars with Jesus fishes on them, as we figured they were charitable people.

The night before, we played with fireworks. While doing so, Tyler (our roadie) wasn't sure whether to point a firework straight forward or up to the sky. Unfortunately, he shot it sideways despite our yells to do otherwise. The fireworks flew towards and then hit a beautiful cherry-red 1967 Camaro that happened to be driving by at that late hour—an uh-oh moment. The driver got out of the car and confronted Tyler. He was upset because, apparently, he liked his beautiful cherry-red 1967 Camaro. All would turn out well with this incident, though, as Tyler agreed to pay for the damage. We were lucky, as the number of gruesome accidents fireworks cause is alarming, and they aren't to be fooled around with, really.

Sometimes in life, variables coincide, and you do something stupid, which becomes much more stupid due to being done at just the wrong time. A twist of fate or coinciding incidents that are "meant to be." Meant to be, maybe, but that's not always a good thing. Will it become a

good thing? Maybe not inherently, but as a means to an end, an event that would lead to a lesson that would prevent a greater future bad? Sometimes.

Things were going well for now. There's something wonderful about travelling with friends, visiting places you've never been before, and meeting new people. People whose individual styles would vary slightly from city to city, which I found interesting. I learned how big and diverse this country is. It was so kind how people generously shared their houses with us, giving us a place to stay when we played in their city. These homes facilitated the collisions of stories from either side of the continent and in between. I learned that as important as a physical home was, it was the people who made the best homes. You can face all sorts of discomfort, even suffering, when you have someone to laugh about it with later.

Spaces to Speak From

Timed just right, the punchline had them both chuckling, with the joke-teller wearing a smug expression of self-satisfaction. The two of them were sitting in the corner on a date among all the other people. This was a late-night gathering of various walks of life, with certain folks there who were louder than others. Some people were playing cards at one table, and some were having after-date chats. A generally lively place at times later in the day, with the odd obnoxious drunk who had to be asked or forced to leave. I miss this space, but I mostly miss the people it enabled me to meet there. My friends would gather at this all-night diner after shows. It was my favourite, called Gerry's, and suitably owned by a man named Gerry, who had moved here from Saskatchewan to open the restaurant, now many years ago. Gerry was a grumpy old man with heart problems. He would let you sit in his diner for as long as you wanted, even if you just ordered a cup of coffee. I'm sure this policy wasn't very profitable. Once, a few friends and I stayed there all day *and* night, calling it the 24-hour Gerry's challenge. We sat, ate, and talked for 24 hours, with different people visiting at various times.

I thought the food was pretty good at Gerry's. I'd often enjoy a greasy grilled cheese with fries and a hefty, less-than-healthy side of ketchup and mayonnaise. This was usually accompanied by "not the best coffee" or a standard Coke, no matter the time of day or night. I was sober but would take part in some extreme eating and coffee drinking. I'd also smoke cigarettes while we talked, as this was a time when you could still smoke indoors and a time when we were stupid enough to risk getting cancer and all sorts of other health problems later on. This sort of attitude, unfortunately, can be pretty common when we're young. However, choosing immediate over ultimate realities is something everyone struggles with to some extent. As for other exceptional consumptions, I would eat three or four sunny-side-up eggs whole, one at a time, each with one big slurp. And I once drank 20 cups of coffee in one sitting. I was lucky I didn't have a heart attack from that. I wouldn't recommend trying it yourself. We took the train and then the bus to get home that night, and I've never had to go to the bathroom so badly. The people I was with lacked sympathy because my situation was self-inflicted.

Other than my usual friends, I'd sometimes sit and play bridge with a group of kind men who also happened to be gay. I thought they were particularly decent and friendly, some of this was because they were hitting on me. I didn't mind and found it flattering; they knew I wasn't gay, and it was harmless and playful. They opened up to me about being gay and talked about some of the struggles they had, as well as gave me insight into gay culture.

So many good conversations were had there, with so many lovely people. There and sitting in Jacob's car, I began dancing with big ideas and questioning everything and anything through dialogue and jokes. We'd talk and argue

about the band and do our best to resolve issues, some of which would pop up repeatedly. Regardless, we'd continue our efforts to understand each other, communicate better, and share our food, coffee, and words at places like Gerry's.

Places like this are so important, where you can be exposed to different walks of life, exchange stories, and vent about the troubles of your day and general existence. A space where suffering can be articulated and lose some of its weight. Saying something out loud to someone helps us change our relationship to what's been said. We reconstruct our roles in situations and gather others' insights, which allows us to find peace by injecting more realism and nuance into the picture. Gerry's was a place for these things to happen. It's gone now, and so is that time in my life. But I'm grateful to have had the chance to, in some ways, grow up there and have the opportunity to build connections with people. I carry a lot of memories from this time.

We need significant places in our lives for good mental health, ones that provide the space for people who make a lasting impact, even when they are no longer part of our present. There's proof of these sorts of impacts in how we hold shared moments in our memory. It's with stories that we pass on some of the essences of these people, transferring past narratives into new phases of our lives. In life, we transmit signs of our happenings, though much is now seemingly lost, the data from glimpses abandoned if only unconsciously. Some tales remain, having proven their worth by being the ones that persisted, becoming mythological if only for ourselves. But myth is usually shared when the impact of a story lands in more than one mind. I've been fortunate to have this sharedness at Gerry's and other places and recently with my partner and her family.

Our sacred place is our house, where we sit around and talk, mostly every evening, about our days and do

deep dives into ethics and spirituality. We sometimes repeat stories, but I don't mind. Every time I hear them, I learn something new because, as with every good story, there is an infinity of interpretations and new angles that arise with each instance of them being uttered.

Our mythologies have blended by listening and projecting sometimes passionate declarations of long-kept fables. I think stories are some of the most sacred of "things."

There's something about a story that is hard to capture, something about it that can be partially conveyed artistically and subjectively but not with any scientific accuracy or full encompassment, an accuracy and totality we crave. It's with a story that we connect to our communities, and it's with a story that we disconnect from everything deemed unimportant to talk about. For some, that's beyond the physical. What is a story, if not extensions of the physical, rooted here and made to happen by our star-dusted bodies? Although stories emerge from us, it's possible their true roots, their home, lie elsewhere, beyond our united verse.

The Universe May All Be One, But It's Not All Good Here

The feeling was profound. It was as if our great sky came catapulting down to earth and became grounded in a wide-open crispness. I stood there as an optimistic 21-year-old, listening to the epic melodies often played at churches like this. Tears were running down my face. What a wonderful release I felt. Peace. Jacob was to one side of me and Avery to the other. Avery put his arm on my shoulder and nodded to me knowingly. I felt at home with them: we had become brothers. Our outlook from this belonging was pretty good these days, and we were living privileged lives from many angles.

I still had some issues with the institution of Christianity and questions about the problem of suffering. But, at this point, I'd chosen to believe that it all somehow made sense from a broader perspective. That there was a Higher Power, and everything would be *OK*. It was a leap of faith, a suspension of disbelief. I was feeling mostly content. Our band had built up a good following, which I was grateful for. But we were starting to argue more frequently. This wasn't great, but it was a minor problem compared to what some

RECONSTRUCTION QUEST

of my fellow humans were facing. Far from my frame, some realities would have tainted my bliss, maybe leading me to have different beliefs and make other choices.

There was the suicidal woman, a few kilometres south of the church, living with trauma and untreated mental illness. The neurodivergent kid who, because of ongoing bullying, felt so desperately alone that they turned to self-harm. A child a few blocks away, born into an abusive home, nurtured in such a way that he would likely continue an awful cycle, blurring the lines between villain and victim. If God had an all-encompassing purpose for us all, it would include these people, along with the space He'd made for euphoric feelings of contentment and belonging. Isn't everything meant to be if there's a divine plan? As much as I now question the theory that we were designed intelligently, if there is a blueprint for my life, feeling those feelings of contentment and peace at that church is a section of my life I'm grateful for and would like to keep in my memory.

Standing there with my friends, I wasn't pondering the problem of suffering; my ears were instead filled with soothing sounds, and my eyes were occupied with the pretty lights. My optimism was safe as long as I stayed where I was, away from the reality of what seemed to be a lack of *luck* out there. The weight of everything, of my mental issues, seemed to fade away like they were solved. For whatever reason, in that church, *I* was allowed a divine moment, one that was opposite to some moments other people were experiencing outside. I was lucky to have this religious experience. I had made choices that got me there, but in so many ways what led to that bliss was *given* to me by some divine force or by randomness. At that point, I was spared the extreme suffering that the Higher Power also seemed to facilitate or at the very least *allow*. I was given joy, and they were given suffering.

Of course, it's not so black and white. We all exist with varying degrees of pain and happiness. With some happiness leading to agony and some suffering leading to joy—making it very complicated to judge who is luckier than anyone else. Luck doesn't entail responsibility. When someone's unlucky, they're not responsible for that lack of luck. It's said that we make our own luck, but I disagree. I get what people mean by that, but setting yourself up to be lucky is discrediting the luck, which is yet to be decided. Luck is typically understood as an external force or circumstance that operates outside human control.

A lot of what makes the people who emerge from suffering better or worse off is luck. Things like genetics, the environment the person was brought up in, and previously imposed trauma are all things that aren't chosen. Or maybe they're selected by some Higher Power, and it's not random. Perhaps it's a divine plan that we end up where we do, but wouldn't it be a matter of luck as to which part of the plan would be imposed on you? We do have some control. Whatever part we receive, whatever hand we're dealt, the results from those cards differ, depending on how they're played.

Some people go through traumatic events and come out with greater strength, gratitude for life, more meaningful relationships, or a renewed sense of possibilities. Others go through the same experiences and come out with mental health issues, further trauma, or a diminished sense of self-worth. Some people hear success cases of folks overcoming their circumstances and use them to justify their belief that since *someone* rose above their circumstances, *anyone* can. But many people don't get the chance to reach a good end to their awful beginning. Some are disadvantaged by the card hand they receive, whether it's delivered by divine plan

or randomness. Can we blame them for not making the best of an awfulness when so many factors worked against them? Recognizing the influence of our power to choose makes having compassion toward people easier. But we are responsible too, though. We aren't entirely powerless to luck. We may not have control over what happens to us, but we do have power in how we *respond*. We can choose our attitude after life's impositions, or we can use that freedom much less positively. Sometimes, it might seem disrespectful to make something positive out of horrific things.

At this point, in the church, I willingly submitted to life and found myself with a sublimely optimistic view. There might have been other ways to approach my situation. Or, views I could have been aware of that would have tainted my experience of what felt like heavenly love. But this was not my position. I had yet to face the trials I was about to. I had yet to face a part of my story that would be deeply awful, albeit deeply formative. Events that would impose upon my "all is love" spiritual view and forge me away from my optimism.

Such impositions are so profound that they reshape our lives in ways that are difficult to comprehend or accept. Change is a constant in life, and I was about to learn that my good luck would soon change, which would profoundly affect how I was willing to react to life and how I was willing to paint the picture of my self-perception.

End of an Era

A few months after my spiritual experience at that church, hostility within our band was escalating. The arguments were getting worse and worse. This troubled me. I had grown tired of the circular conversations. We gathered at Gerry's to discuss things and make a game plan. After discussing the situation, we decided that it was best to break up. We organized our final show, and in a matter of weeks, we were all standing on that stage, getting ready to play our songs one last time.

I still hear him, with that strong calm presence, which is an example of his outstanding leadership. Avery looked at the crowd of around a thousand people and yelled into the mic, *"Look at what you built!"* But it was his doing, too, as *we* built homes beyond the material and revelled in rust-orange vans. Built scaffolding for restoration to heal from the impositions of our past. It was an important community Avery helped create, and it would continue long after I left. Our band's end was complicated, but I don't think we fully realized what we were losing. I certainly didn't. It was a time when my mental health was at a peak, when any hardship was significantly minimized by the purpose and

hopefulness we found in each other. When the band broke up, I drifted apart from many of my friends, for no good reason other than that we were growing in different ways. I had gotten into my first serious relationship, so I had less time, and priorities were shifting.

A lot of the friend group was also starting to do different things. Antonio had gone to England, getting a great job working in the airplane industry as an engineer. Jacob was training to become a pilot. Life continued its march forward, with some movements bringing people closer and some apart. We didn't all move on from the hardcore scene. Avery continued his involvement with it and contributed to a new generation of showgoers. Soon after the band called it quits, the relationship I was growing had some profound moments to be grateful for. We became very close. This got me involved with a family who welcomed me into their lives and gave me a job at a commercial shop the father owned, with, funnily enough, Antonio's dad.

When that relationship ended, due to fights that would repeat and were seemingly impossible to resolve, I had a lot of pain to deal with and entered a very dark place. This breakup was formative, but in a way that destroyed my optimism and built cynicism and callousness. It was difficult for me to imagine a future different than the one we lost. To cope, I regressed to *using* cannabis more and more as the months went by. The same thing happened with my drinking. I made some toxic decisions during this time, being careless out of apathy. I became comfortable with being the sort of person who was destructive, and so it felt OK to make destructive decisions. What helped me from being completely damaging was a new relationship I started about a year after the breakup, which continues to this day. But even she couldn't stop what was to come.

Amid the struggles of the next few years, there were plenty of great moments, my new relationship with this incredible woman named Adreanna being the highlight. I had mostly drifted away from the local music scene, but I did some more touring with different sorts of bands. I was accepted into art college to study graphic design, which was exciting. Still, I was struggling to find my way in the world. My mom worked as a Christian minister at Oak Park, and I stayed at her condo, a few blocks away from the church. I was making art. A notable project I remember is when I mounted a chair on the wall to photograph people in. The absurdity of sitting in a chair on the wall was so satisfying. People couldn't help smiling when they sat there. I was putting my creativity to good use, which makes me grateful to have the brain that I do.

This was one of the projects I worked on in school, which had a community in its own right. I made some new friends and was free to explore all sorts of visuals and concepts. Art school was fantastic and fostered my diverse brain, but it would, unfortunately, lead me to become obsessed with certain philosophical ideas, which, coupled with upcoming stressful situations and adverse experiences, would contribute to me arriving at a very inhospitable place.

Reconstructing the Storm

Making the Best of It Feels Like Disrespecting It

I was at the art college late one night, about four years after the band broke up, a determined 23-year-old working on a project alongside some friends who were working on their own. I had taken a picture of a fast food restaurant that I'd seen catch on fire. I photocopied it repeatedly until it got so distorted that it was unrecognizable, and then cut up those pieces of paper and arranged them on a canvas to make a new version of the original picture.

I'd recently gotten high in the stairwell, which was a vibrant place—completely covered in graffiti. It was a nice, warm spot that served as a refuge from the winter night and a great place to congregate and share a moment with someone. The security guard would show up every once in a while, but he would mostly just get you to stop and shake his head.

I saw that my phone was ringing. It was Jacob. *How nice*, I thought. We hadn't talked in a while. I picked up the phone, not knowing what I was in for. Jacob, with tears in his voice, broke the dreadful news that Antonio was no longer here in physical form. His body was due to return to the earth, with his essence's whereabouts unknown. There had been a hiking accident.

I was in shock, and it didn't help that I was stoned. Antonio and I had stayed in contact a little bit but had mostly lost touch. I now wished I had taken more time for him and reached out before it was too late. We sometimes feel like we have all the time in the world, but we never know when fate will give us a cruel hand, shrinking our options. It felt like yesterday that we were pushing a shopping cart full of socks through Walmart, soon to deliver them to a local homeless shelter, with money the church had given us to do something good with. These and other memories filled my mind, now with a different significance. How could Antonio be gone? What a frustratingly fragile life this can be. I hurriedly packed up my things and took the train home.

He was so young. He was just getting started with a career in engineering at the airplane company in England. On the bright side (is it even appropriate to find a bright side to something this horrible?), his time on this earth had been full of beautiful moments that he shared with us, his friends, as well as his family, his parents being some of the greatest people I've ever met. I'd go on to strike a deep bond with them.

I'm not sure if I'll ever get over Antonio's death, and to be honest, there's a big part of me that doesn't want to. In my mind, I keep some "scars" as sort of personal badges as a way to honour those who have passed. In a world where time has a way of erasing memories, these "scars" serve as reminders. They're painful to bear sometimes, but maybe there was solace to be found in that Antonio was now transformed into a different form of energy, as well as living in our memories, being held in our hearts. We also have rituals, rituals where we can re-enact memories to honour their importance.

There was a wake not long after I heard the news, where the family and friends of Antonio gathered to celebrate his

life. We put together a makeshift band, and I was honoured to perform a cathartic guitar solo while playing Neil Young's "Rocking in the Free World," among other songs that were difficult but very meaningful to play.

At the end of the evening, as people were shuffling to their cars, emotionally drained from such a hard but necessary night, I asked Antonio's dad if he was OK. *What a stupid thing to say.* He replied yes, but good God, what suffering there was now and in more moments to come. Wasn't this God the same Higher Power who had facilitated my pain as an innocent child, who had created a system which enables so much pain, who gave or let us live with a variety of luck?

I suppose these could be seen as learning opportunities—but that doesn't seem right. If there needs to be the option for pain for there to be the option of joy, an all-knowing God should have been able to come up with something better. Why allow such suffering, like the loss of a child, even to be possible? *Ah, but the child is not lost,* a Christian might say. There's a big part of me that believes this. The best answer I've come up with is in the word's of Shakespeare's Hamlet: "There are more things in heaven and earth, Horatio, than are dreamt of in your philosophy." Antonio, what place are you in now? Somewhere making more people laugh with that clever cynicism of yours, I imagine.

Amid grief and questioning, we continue to honour Antonio with our language rituals, re-enacting the moments that made him so dear to us. While we may never fully get over Antonio's absence, there's beauty in keeping his spirit alive within us and in the stories we share. Perhaps, in the enduring connections we forge, there lies a glimpse of something greater, something worthwhile, with the sense of it simply out of frame.

Becoming after Loss

After Antonio's death, my view of worthwhile light became more and more clouded and obscured. Apathy crept further and further into my psyche due to loss and frustrations. I continued to use the tortured-artist label to justify my lack of self-care and isolation. *This is just who I am*, I thought—*it was handed to me and it's unchangeable.*

There *was* a lot out of my control that took its toll on my willingness to give a damn about life. Unfortunately, the need to grieve in our friend group continued when Jacob's sister Julia, as well as two other women, Sarah and Madison, passed suddenly just eight months after Antonio—another event that challenged my optimism and fueled my cynicism. Tragically, there was a car accident south of Calgary, which marked the end of Julia's, Sarah's, and Madison's earthly deeds, along with the driver of the other car. Julia, Sarah, and Madison would sometimes stand in the front of the crowd while we played. I still remember their brilliant smiles and eagerness towards life. The light in Julia's eyes, the optimistic smirks, and the youthful demeanour of all three of them. What a loss for the world.

As for me, I was not doing well. My mom had recently moved to New York State to be with a new partner, and the condo was put up for sale. It was my responsibility to help show the house to prospective buyers, which, along with my art school schedule and musical performance schedule, was contributing to escalating stress levels. It sold quickly, so I needed a place to live. I started to explore my options and ended up finding an opportunity to live in a small house in downtown Calgary with a roommate, a friend of mine named Orlando. I'd have some memorable times at this new home, but ultimately I wasn't on a very healthy trajectory. I was dealing with grief and struggling with my mental health.

I wasn't attending that many local music shows anymore due to anxiety, and this was its own sort of loss. I was becoming increasingly isolated, and my thinking was gradually becoming more and more *toxically* eccentric. I was becoming progressively less and less proud of being a self-caring agent and more and more proud of being what I thought was some admirably self-sacrificing and chaotic artist. This lack of healthy pride was reflected in how I wasn't taking care of myself. Or, rather, I took pride in different things. I was proud of the art I was making, and it felt like my best work; I was *obsessed* with it. I thought it was absolutely profound (in retrospect, it wasn't). The pain I felt from what had happened in my life gave me something I needed to numb. It was convenient that the cannabis and alcohol did that, as well as made me *feel* like my creative muscles were enhanced. I'd write things I thought were clever, but they were ineffective ultimately—pretentious. Too much of the work was left in my head. Not enough was on the page. The grandiose goings-on in my mind were intoxicating as I *felt* all these variables flying together in

beautiful harmony, a harmony that was missing for other viewers, as they had their own perspectives that would have required more on the page for the work to be palatable.

That's not to say that making this art during this time wasn't worthwhile. It served as a way for me to use my energy, brainstorm, etc. It wasn't finished work, but work doesn't need to be completed or even "good" to be worthwhile. There's value in how the process helped me therapeutically, outside of the value of what was produced. Some of the art I've made while sick was, to me, successful. It's important for me to recognize even now that channeling that volatile and unavoidable energy is different than chasing that volatile state to make art. The latter so often leads to pain, as we're overcome by the wave we try to ride. Also, it's very harmful to justify staying in a toxic state because of the art one produces from it, art that from my experience, would be even better if we were well.

Good art or bad art, I neglected my health because I felt justified by the character I had adopted for myself. It was in a slow and steady decline. I was getting lost in online encyclopedias, sure that oscillation and contrast had some deep metaphoric quality and that "many and one" was a sacred root axiom. Everything was dualistic or triadic. The left and right hemispheres were related to the yin and yang. I was on my way to discovering some grand unified theory. Particle, wave—we were both and none. Some of this had merit, but I was mostly making things out to be related that just weren't. Trying to simplify things that became false when simplified further than they already are.

This was a time when I *perceived* myself as exceptionally brilliant. Yet, in reality, I was progressively becoming more self-righteously grandiose and less mentally sound. My brain was increasingly reflecting the characteristics of

mental illness. I was becoming less and less well. I went overboard with how I saw myself and wrote my character as if I were some supernatural protagonist or saint. Although there *are* excellent parts to me (humble, too!), there was no evidence for any of my supposedly extreme excelling during these times. I *do* excel creatively when I'm in a state of sobriety and good physical and mental health. I have a certain clarity and vitality when I'm of sound mind. All this allows me to tap into my full creative potential and produce work that is meaningful and reflects the best of my abilities. It's work with enough access points for impact to come across and land. When my identity is expressed in this way, the dial is further from mental illness and closer to the positive aspects of neurodivergence. At this stage in my life, though, I was inching closer and closer to the other side, that negative sword edge growing sharper quickly. It wouldn't be long before my life would transform further into mayhem and be turned almost completely upside down.

Fractured Momentum

I was in the small house downtown I'd moved to after living in my mom's condo. Situated between two larger buildings with a forest-green door that had been put back together after a break-in, it looked out of place, being so small compared to the apartment buildings on either side. The only reason it hadn't been turned into an apartment building itself was that the owner was stubborn about selling. The house was run-down but had great character, and I loved how it looked out of place but had persistently remained.

A week before, I returned from a trip to New York State to visit my mother. When I got home, I played three shows, two out of town, and had three assignments due at art school. It was a busy schedule. I was now in the living room, painting on the back of a canvas with red paint, convinced there was some cosmic relationship between an ex-girlfriend who loved the colour red and a person named Mary I had met recently who then died. Loosely related things and people were flashing through my head. I chuckled to myself, feeling clever, like the universe's secrets were unfolding inside my skull. However, this was no genius. I was drunk on noise.

My friends and family, burdened by this outlandish phase of mine, were not equipped to give me care. Though, in their defence, they did the best they could. Some would humour my out-of-touch theories, while some would try to change the subject to something more practical. At this point, I was by myself, so I was free to let any wildness that came to me blossom and grow. As good as this felt, I was a wreck mentally *and* physically, with dirty, long hair and a skinniness that shocks me when I see pictures of it. I didn't shave, reeked of weed, and perhaps most dangerously was sleeping only a few hours a night. Looking back, I wonder how I had gotten to this point. I wonder why I didn't consider the feelings my parents must have felt seeing my life unfold, or rather unravel, like this. My dad had come over the day before because he was so worried, and I had made him very upset, and he rarely got very upset. Awful. Oh, the power we have to make things worse for someone in the vulnerability of love.

I wasn't harming them on purpose, but I was following what I thought was the right path to take, which was ultimately self-destructive. I didn't realize though how certain immediate choices were responsible for a dire ultimate reality. I wasn't sleeping, and this is a huge warning sign for me. In retrospect, I wish I had made more of an effort to get more sleep. But I have to remind myself that I was doing my best to survive what had been a hell of a past few years. No, I didn't choose the events that were unravelling me, or to have a disposition that was so deeply affected by them. At this point in my journey, I didn't know how much I could take. And I was enjoying myself immensely, getting caught up with apparently visionary pursuits.

Let's be honest. This eccentricity I was experiencing could easily be labelled as psychosis and mania. There are

many different words for this sort of thing. You could say I was "out of my tree," crazy, a nut, and overcome with madness (albeit with creative elements). Neurodivergent, maybe, but this would be neurodivergence expressed toxically, with toxic outcomes. Other factors caused this rupture, such as the stress from my responsibilities and likely the cannabis use.

But, it was the sleep-deprived trip to New York State a week before that had given my fractured momentum new speed. I visited my mom and her new husband, Derek. Derek had fought in the Vietnam War and was a strong personality. He had been through a lot in his life. We got along well and I liked him. He told that he had watched his friends get killed by friendly fire and that he was scorned by the anti-war activists when he returned to America. I'd never heard such first-hand experience of war. I was sympathetic and captivated. I felt for Derek, but unfortunately, I'd learn about his dark side. Life is complicated. The lines between victim, hero, and villain can be blurry sometimes.

Derek gave me a US Army jacket, which was precious to me. It felt like a great honour to be dressed like a soldier. Isn't it an important job when the cause is worthy? I wore this jacket as we drove around town, finding houses to photograph that were abandoned but had weathered beautifully. The trip was going well, but I wasn't sleeping. I spent my nights writing about war, childhood, and everything in between. These scribbled-down notes felt profound.

Instinctively, I read Derek's Army hand signals as we went to chop down a tree. He had taken me to the forest on the last day, and after we found wood for the fire, he pointed to a spot in the forest. He spoke about how it was an opening to another realm and that I would feel differently after seeing it. If not right away, then when I got back to

Canada. I certainly did, but I was also well on my way to madness at that point, although I must admit this is one of those details that I find eerie to this day. Was that really a portal that changed my psyche? It feels ridiculous to humour this now, but there are more things in heaven and earth ...

I flew home feeling out of it, but was happy or rather between moderately and majorly delirious. I accidentally left my passport and those notes I had written in the washroom of the Calgary airport. When I discovered I lost them, I did my best to be stoic and calm. *This was a test*, I thought. Luckily, the airport called the next day to tell me they had them. I assumed this was a reward for my faith. I picked them up, drove home, and then had to work on projects that were due at school. I spent the next week busy with schoolwork and music. Once I had some of those responsibilities out of the way (which I'm surprised I managed to do), I'd lose myself painting with red paint and scrawling symbols on the back of the canvas. This was to be one of the images for the album artwork that I had been working on off and on while I was going to college. I let my mind go entirely while doing this album art, thinking this would help me create masterpieces. It didn't, but I can't deny that it served as a stepping stone for where my work is now.

While I was painting, I started to get emotional. I sat there crying with the crimson-red paint on my hands until Orlando, my roommate, entered the house. He did his best to console me but he had to go to work. I decided to join him on his walk there, so we left the house together. What a crisp freshness there was in the air, and Orlando tried his best to talk me down. It must have been quite the sight, now with my army jacket on, with red stains on my hands, tears streaming down my face. We walked by a store with its walls being painted a pristine white. One of the painters,

our friend Tyler, came out to say hi. There I was, looking like someone to avoid. Tyler didn't flinch. Didn't put his nose in the air, didn't laugh at me, and was unfazed. Looking back, I'm impressed by this: it's an example of how most if not all of my friends acted reasonably in a very hard situation.

We continued our walk until Orlando split away when he had an emergency to deal with at work. I was now on my own, and the walk became a pseudo quest, a psychotic meandering and apparent puzzle-solving session on the streets of downtown Calgary. I had to find the right place, do the right dance, and be the right person. The whole thing was a setup for a music video. There must be hidden cameras everywhere. I felt somewhat invincible, so I rolled over the hood of a driving car like I was in an action movie. I was lucky I didn't get run over. I continued to dance my way through the streets until it occurred to me that I needed to prove that I wasn't attached to my earthly possessions. So, I took off my army jacket and threw it to the ground. I tossed my phone around, laughing maniacally until it exited my grasp and smashed onto the pavement. I eventually ended up on the second floor of a building, where I took my sweater and T-shirt off. Someone in a nearby office called the cops. I sang and cried, spewing mostly word salad. My hands waved while I stood almost naked, shivering in the winter cold.

I saw a cop climb up to see me while I was contemplating jumping off the building. I thought there would be something there to catch me. *I just had to have faith.* Later, the doctors would use this incident to indicate that I was suicidal. I may have been engaging in what I call a sort of soft suicide by how I was living. But, at this point, I didn't want to die, as it felt like I was *so close* to some big reveal, where I would see proof that they had been filming me, the actor, famous and wealthy. What saved me from jumping was that I had a

small amount of insight and critical thinking left. It felt real that a trampoline was there, but I couldn't jump unless I was sure. The delusion told me I needed faith, but I refused to believe it fully. This has happened a lot in my illness, where I've been close to total conviction but not convicted fully. When there's some working insight, we're not entirely delusional. It's a spectrum.

The police were kind and helped me down from the building. A psychologist arrived and looked me straight in the eyes. I thought I heard her say she was God, although I saw her later and told her this, and she informed me she hadn't. She did say, though, that there were certainly worse things she'd been called.

They decided I needed to go to the hospital, so I was taken there. The car ride was strange, with the cop's screen morphing around with my name multiplying and lessening. I sang Paul Simon's "Graceland" for them, and they told me I had a beautiful singing voice. We arrived at Foothills Hospital and I was put in a room with magazines. I had it in my head that they were using my choice of magazines to diagnose me, so I needed to pick the right one. I would eventually be taken to a hospital bed where people hovered around me. They gave me an injection, and a voice inside my head said I could choose my death. I felt a thud going back and forth between sides of my skull, and then my perspective, my consciousness, it disappeared.

Woe Is and Isn't Me

What a strange place I found myself in. The aura felt utterly dystopian. I hadn't been anywhere like this before, I knew that, and I hadn't *been anyone* like this before either. It's hard to articulate exactly what was different about me entirely. I had lost my freedom, but more importantly, my mind had cracked like an egg. I was in a run-down psych ward room, although I hadn't accepted it as such. It felt like a maze, not a hospital where people were helped. I felt condemned. There was no escape.

The first few days of my inaugural week are lost to me, like the blackout portion of a highly drunken night out. The only distinct thing I remember is rummaging through another patient's space while they weren't there, searching for a key like I was in an escape room or a videogame. I opened drawers and searched for clues to achieve some big reveal. Awful. After those hours of darkness, a general feeling of unease followed. I was in a game and felt I needed to figure that game out. I was obsessed with making "the right move," although whenever I thought I had, it was like the board game shifted, and I would be shown a new hint, another promise to save me from this ironically inhospitable hell.

The TV was delivering messages, and I took the words it was broadcasting and made ridiculous conclusions. It was as if my control had expanded repercussions. My actions felt more important than they were. Delusions can be so self-centred. Mine were all about *me*. How I was the hero, or I was a villain in danger. From my position, the only one I have, I bounced back and forth, being either an elevated figure or one who was soon to be condemned. It was a gauntlet, an obstacle course known as Unit 21. The rooms I had to explore were limited, and some that I entered led to confrontation. One man yelled at me for opening his door, so I scurried away to find something else to figure out. My behaviour was strange, but there was no shortage of peculiar behaviour in the psych ward, and I would have to reckon with being there for a while.

I had been "put on a certificate," which in Calgary, Alberta, Canada, meant that they could legally hold me against my will for around a month or until they deemed me fit for release. As much as restricting the freedom of the mentally ill is controversial, I was arguably much better off in the psych ward than out and about singing word salad to strangers, stressing out my family, and possibly harming myself. I was receiving care from the Western medical system, but I wonder how differently things would have gone if I had been treated by a shaman or spiritual guide. Was I spiritually sick or misguided? Was there understanding or some sort of narrative action that I needed to take, or was it all simply noise? I may never know, but I am open to it. I will say that I think there's a danger in making someone falsely responsible with spiritual interpretations. However, perhaps there's also the danger of making someone falsely *irresponsible*.

As far as I know (which admittedly is little), the content of altered states is meaningful in some cultures. I believe that

some of what I've experienced had spiritual significance, but much of it seems to me to be pure fiction. Just noise (though fiction is true in its own way, I suppose). As curious as I am about other approaches, I'm grateful for what Western medicine has done for me, but it hasn't been a perfect option. It helped me get to where I am today. However, we can get trauma from being in fight-or-flight mode for an extended period of time, and my time at the hospital was certainly that. I was, for the most part, constantly on edge there, scoping for threats and never relaxing. There was such an intense energy, with everyone battling their minds in some way or another. There was a mental battle, but there was a physical element for me, too.

For the first week, I had no privileges to go outside and endured the withdrawal from alcohol, cannabis, and nicotine. This was more than uncomfortable. Woe is me, right? Though some of my decisions helped get me to this psych ward, the outside influence on those decisions was there, too. I hadn't chosen to have sensitivities that became overwhelming. Although I could have channelled my emotions in more productive ways, I didn't expect my efforts to help myself with self-medication would contribute to something like this. There were other factors. I played three shows, experienced all that loss, the stressful trip to New York State, the assignments being due. I thought I could handle all this, but in the weeks before my first psych ward visit—I was overwhelmed.

Woe is and isn't me. I hoped to be at least partially a victim. I didn't realize psychosis was in my future when I made those contributing decisions. Isn't responsibility interesting? Though as interesting as it is, focusing too much on who or what's to blame can be like focusing too much on a rearview mirror. I recognize the irony of me writing this

in my memoir. Perhaps it's about balancing our looking backwards while being grounded in the present. All while keeping the future in mind. Perhaps the Higher Power can experience all three at once. However, I lack a God's Eye View to be definitive. So, I've had to become comfortable with the limitations of my view and embrace the unknown. For the wrongs I'm confident I was guilty of, it's been important to forgive myself and keep my self-talk in a positive direction. This isn't always easy.

Whatever factors are to blame for my illness, I can't go backwards. I will never be the person before my first mental breakdown, and that has been a real loss. But I've learned that my transformation was also *a good thing*. Before this psychosis, I was guilty of being arrogant. I had an air of recklessness. Madness humbled me and made me realize that since I'd experienced how wrong perception could be, it made no sense to be so self-assured with certain matters.

At this point, though, I was far from that result of humility. This was the beginning stage of what would be a long journey. Now, on day 6, I shuffled through the hallway, fighting the assumptions and extrapolations my brain was making. I was on guard. I scanned the hallway and saw something that seemed important to be aware of. Leaning against the wall, hitting his hands against each other, was a tall and bulky man who was red in the face. I quickly looked the other way so as to avoid attracting attention, to avoid an encounter with what seemed to be a dangerous character.

Scared

That guy freaked me out. There was something about his presence that I found very unsettling. It was the intensity of his eyes and how he paced around. He seemed like someone I'd be wise to avoid.

Being in the psych ward had its challenges, but the medication they put me on was helping me get better day by day. I was anxious but began regaining some basic social skills. Thankfully, I was becoming stable. I credit this to the antipsychotic pills as well as to how I persevered through all the false beliefs I was generating or had thrown at me. About a week and a half into my stay, I was involved in the same group activity as that man hitting his hands together. I was hesitant initially, but funnily enough, I became friends with him. He turned out to be surprisingly nice, and we'd soon be passing the time listening to music while talking about life. I learned that he was here because of having too many concussions playing hockey, a cause of psychosis I wasn't aware of at the time.

During a conversation one day, he said, "You know, John, the first time I saw you, I was genuinely scared. I thought, *I should keep my distance.*" I smiled, "It's funny you say that because I felt the same way about you."

He grinned back at me and slowly nodded a few times. I thought, *I could have been him, and he could have been me.* We sat in silence for a while, listening to music. After sharing a few songs together, I had the urge to move to another room. Feeling encouraged by the conversation, I wanted to try playing the piano I had been tempted to play for days in another common area of the ward.

Keys

With my two hands working together on the piano, I played a gentle melody that seemed to change the room's mood for the better. It was a hopeful and whimsical sort of song, and most people stopped what they were doing to listen. The arrangement was therapeutic to play, and I was flattered that others enjoyed it too. When I finished, I turned around, and one young man stood a few feet away from me with tears in his eyes. He had a look of contentment on his face, of joy. Whatever praise I felt from his reaction, I knew it was better directed at the musical spirit I was channelling. In contrast, the emotions that were generated in the psych ward were often unpleasant, as if someone in the sky were firing down clashing notes at us repeatedly. Whether it was or wasn't of our own making, there could be a lot of chaos, a lot of pain. I was happy to contribute a musical reprieve, and using some of my brain for what it was skilled at felt good.

My piano-playing skills were better than before. Previously, I had trouble using both hands simultaneously on the instrument, and changing chords was difficult. It looked like abstaining from drugs and alcohol and being on medication was helping me with my musicianship. Step

by step, my mind was returning to planet Earth, with a gradual lessening of the disconnection from the shared real. I felt determined to continue this momentum, motivated to change my life because of the suffering I'd gone through. I knew I needed to keep persevering and be as optimistic as I could be, and I wanted to spend the least amount of time in the psych ward as possible. It was one of the hardest things I've been through. I clawed my way upward and endured the worst of my paranoia and other delusions. I was still struggling with outrageous plots and ideas, but I was in much better shape than I'd been a couple of weeks earlier. I was stepping back, thinking about my thinking, and doing my best to be critical of my beliefs.

It was now 2 o'clock, which was when visiting hours started. I walked to the entrance and saw Antonio's mother, Rita, enter the room. She was wearing a beautiful jacket, with such a strong and vibrant red colour. Tony, Antonio's dad, was there too, and we left the ward to wander the hospital halls. As we discussed how I was doing, I felt relieved they were there. They were both so kind and encouraging, as always. Around an hour later, some other people arrived to see me. Adreanna, my fiercely loyal partner, was there. My mom had flown in from the US, and my sister and her husband came to the hospital with my dad. I was lucky to have more visitors. A significant factor in my recovery was that I had the support of my community. Isolation makes an awful situation a lot more awful when you're mentally ill. I spent the next few hours explaining some of my worries to my friends and family and was assured that most of what I was thinking wasn't true. It was beneficial to do this, and I was well enough to trust their perspectives.

Soon, my visitors left, and I returned to the piano, back to ring its various tones. The melodies were mostly

improvised, with notes that worked together to do their mysterious thing, repeating patterns and grounding low pitches. The sounds blended in and out from each other and served as a warm distraction from our troubles. After 10 minutes or so, I lifted my hand to play a final harmony and let it resonate until the notes faded into nothingness. Standing up from the piano bench, I went to sit somewhere else for dinner and was happy to hear a few claps from my audience of fellow misfits. I grabbed a plastic tray filled with "not the best food," as described by Trevor, whom I was now sitting next to. We said hello and then he thanked me for the songs. I was grateful for him. A few days before, he'd helped me when I had a panic attack, walking me down the hall with his arm around my shoulders.

Away from the table was Kate, who wasn't eating yet, standing by the TV and muttering to herself. I heard her say the alphabet backwards perfectly once. An impressive feat, though the world works with it forward. Sitting across from me was Alex, the Zen Buddhist with whom, earlier today, I'd discussed the ancient proverb, "Pain is inevitable, suffering is optional." We couldn't figure out if it was pain or suffering that we felt from trying to figure out the proverb. Walking over to sit down was Luke, whom the next day I'd stand face to face with, who would stare into my eyes and tell me I had a pure soul. He paced around a lot and would talk to you like he was delivering a sermon.

I'm reminded now of the chaotic moments that rattled me. Like when the puzzle was smashed, or the chair was thrown. Or the feeling of leather on my body as I was strapped to a bed, a time where stillness never felt so chaotic. One man screamed in conversation with himself, with some projected or invading devil. The confusion, the utter and *horrible* confusion.

But it wasn't all bad. Some people were kinder than others. It was a real mixture of people who were patients here, each in some way battling their mind, each with our own disconnection to reckon with. But tonight was a lively one, a *good* lively. A hockey game was on later, and the couches would soon be filled with people who'd cheer when Calgary scored. Eating had eased some people's moods, and I was happy about the energy of the place. I put in my headphones and began walking around the horseshoe shape of the ward. As I paced around, tears ran down my cheeks; the influence of music and the nature of my predicament hit home. I didn't feel bad for myself. At that moment, I felt a certain strange beauty from being there.

I had gone back and forth on the U-shaped unit a few times, and there it was again—the piano. A wooden shell filled with metal strings, a dynamic vessel that would send a projection of your choosing, react to how your fingers pressed its keys. When played with care, the piano starkly contrasted with the largely chaotic goings-on within our skulls and the undesired environment that so often surrounded us as divergent characters. Yes, the piano was always there, an alternative therapy in a mostly strange place. Like this instrument, surrounded by the troubled and the discontent, it was my ability to play it that was persevering through a storm of its own.

Other People

With the power of hope and optimism, I had now battled my way back to a point where I could be released from the psych ward. Feeling enthusiastic and wanting to continue my better go of it, my doctor thought it was a good idea for me to go to Three Sisters, Alberta, for further treatment. This was a small town about three hours away from Calgary. It was surrounded by a lot of farms and didn't have a lot of industry, but there was also a treatment centre there, which is where I was headed. I was excited to go, eager really, thinking it would be a significant next step in my recovery.

My dad drove us there, and we arrived at around 2 p.m. I began the intake process, quickly noticing the same clinical feel I was used to in other hospitals and the same unpleasant atmosphere. A woman took me near a camera mounted on a tripod for my photo and grunted at me to stop smiling. *Great.* I noticed my anxiety kick in. It wasn't long before I realized that my eagerness wouldn't be a good fit here, which was depleting. After the intake and what felt like a mugshot, I was taken into the area where I'd be staying. People shared small rooms and a common area with many well-used books on a bookshelf. It wasn't a bad

environment. Thankfully, everything was clean. But something didn't feel quite right. One area had a table with chairs that pointed to a TV with hockey highlights playing and a few people gathered around watching. They turned their heads, and a couple of them said hello.

I scanned the scene for a while and was introduced to a few other patients. Soon, another nurse came to take me to see the doctor. I walked with her and entered a small room that was dimly lit and the doctor sat there and introduced himself. He was an average man with a confident aura. He asked me a few general questions about my situation, then told me he was putting me on a drug called Topamax. I'd later learn it was nicknamed Dopamax due to its sedating effects. I eventually found out, through another patient, that *everyone* was put on Topamax. It had apparently grown from being an anti-seizure medication to being used to treat anyone with addiction issues. I left the room I was in with him, feeling uneasy about taking a new medication I didn't know anything about. (It's worth noting that Topamax has been a fantastic medication for many people. My issue isn't with the drug itself, but with any drug being used as a "one size fits all" solution.)

While waiting to see how this new med would affect me, I spent the rest of the day talking with some people and playing a guitar I found leaning against the wall in the common area. We then had dinner and I soon went to bed. I had difficulty sleeping due to the new environment and how different it was from my expectations. When I did get to sleep, it didn't last long enough. I was woken up around 6 a.m. and told it was time for recreation. The rest of the patients and I hobbled to the gymnasium, where we had to do something active for the next hour or so. The least you could do was walk around the gym's perimeter, which is

what many of us did, like zombies going round and round. *Where am I?* I thought. It started to feel like I was in prison, not a care centre.

Exercise time was done, and I had time to go for a smoke before the classes they had scheduled. While walking there, I remembered one of the nurses warning me not to give a cigarette to anyone, as I would become an easy target for the folks getting off opioids in a housing complex next door. My privilege was starting to become obvious to me, as a lot of the patients I was with were in more distress than I was. Feeling very out of place at this point, it was time for dinner. We slowly walked over to the eating area, all in a line. A few people ahead of me was a well-built young man with a fresh scar across his face. He was glaring at everyone and looked like he wanted to pick a fight. I started feeling uneasy, so I ate fast and returned to my room.

The next few days I struggled to fit into the routine. I had a few phone calls with Jacob and other family members, telling them I didn't think this place was a good fit, and tried to explain the situation. The optimism I'd achieved at the psych ward was being challenged. It was frustrating how oblivious they were to the realities of being here. I don't blame them, but they told me I should stay as it was the right thing to do. I decided to listen and stay.

Soon, it was eating time again, so I went to the cafeteria. I finished my food quickly and then prepared to go outside. I saw one of the people I'd gotten friendly with and asked if he wanted to join me. He nodded, and we walked to the smoking area. We talked for a few minutes, and then he asked me a question.

"Hey, you know that guy with the scar on his face?"

"Yeah," I replied.

"He's got a shank that he carved from a toothbrush," he said quietly.

"Oh," I said, although I was thinking *WHAT THE %$&#!* My anxiety increased.

This made an uncomfortable situation worse. I now had to decide if I would be "the rat" or not, which is a role that I've heard from movies and whatnot is undesirable and looked down upon. On the other hand, if I didn't say something, someone could get seriously hurt, and that would weigh on my conscience for a very long time, if not forever.

I decided to tell a staff member. When I returned from smoking, I approached a nurse who was sitting watching TV with some other patients. I informed her that I needed to speak with her in private. She nodded, and we entered a private room where I could disclose what I had to say. The nurse listened intently and then responded, telling me they would handle the situation. Then, continuing with her eerily calm voice, she said, "Thanks for telling me, John, but you know that you are perfectly safe here, right?" I thought, *YEAH, BLOODY RIGHT,* although I responded with a cool nod. I left the room, hoping no one saw me, and went to my room to journal. There was a lot to process. I wrote a few scattered and unresolved poems, mirroring my mental state, wrestling with the implications of the situation.

The next day, the man with the scar was gone. I attended the classes I had to and did my mandatory exercise. But most of the time I was distracted, thinking deeply about that man. *What makes us so different*, I thought? The whole thing made me sad. I bet he came from some horrible

background and found belonging with the wrong group and with toxic influence. I was happy he wasn't here anymore, but something about it all struck me as unfair. I saw it in his eyes. He might have expressed it aggressively, but he was also scared.

Sure, choices had gotten him to where he was now, but the likely unlucky *influences* of his choices made me feel compassion for him. I could be wrong; he could have had all the healthy opportunities in the world, but I doubt that. Deviance is often linked with trauma and poverty, among other factors. But this compassion comes from my lens and where it's pointed at now. Suppose that man had harmed one of my family members? In that case, I might have had difficulty containing my rage and desire for retribution. What would that do, though? The hate would be carried around and cause a *second* injury to me. First, the injury to my family member, and now the weight of animosity.

I'm still unsure what the best way to look at this is. Life is complicated. After being there for a few days, I'd gotten a pretty good feel of the place. If this is the state of our facilities, it's no wonder we have so many mental health problems. We need to do better. Having all of us on the same medication is nothing short of dystopian. Also, exercising that early in the morning isn't for everyone. In fact, I'm highly suspicious anyone would do it willingly.

After dinner that night, I asked the doctor to take me off Topamax because it was making me feel like a zombie. He wouldn't and said that if I wanted to be here, I'd have to stay on it. I wanted off of it, and I also wanted to leave. I left the centre, took a cab to the bus station, and went home. I was wrapped in thought as the bus moved along, with feelings that led to questions I still haven't resolved. If the environment imposed on me differed, could that man

have been me? Did I just condemn myself? What if he had that shank for protection? Why did I get involved? Someone involved me, and doing nothing wouldn't have been neutral, but this institution I may have just aligned myself with was broken as all hell. I might have served the community by saving someone's life, but good God, what a mess this life can be.

Madness / Crazy / Altered State / Nervous Breakdown / Psychosis

It's an uneasy exercise to put yourself in some people's shoes. Still, sometimes in life, you experience something you never thought you would, and suddenly, you're in a category you previously judged. If you told me that someone I was around had a psychotic disorder before I got sick with one, I'm not sure how I would have reacted. In all honesty, I probably would have run the other way. Even once I went mad, I still dealt with the stigma against other psychotics, as well as the stigma I held against myself. We can call it other things, but when the word *psychosis* is used, it's typical for that to be associated with crime and deviance. Most of the examples we're shown of psychosis in the media are of people who are violent and dangerous. In my story, though, the man with the shank wasn't psychotic. The contemplative artist was.

I identify with experiencing psychosis. But I understand the word as many others do not. I realize it isn't a term for chaos and violence. I've experienced delusions and wrong beliefs even though I was convinced they weren't. I've also had experiences that some people would say are delusional/incorrect, but for me they were deeply spiritual

and connecting. Does it make sense to use the same word for both ways of seeing the world? I'm not sure. The term *altered states* may be more inclusive and less biased towards the negative. Perhaps it makes sense to say that some altered states are spiritual/positive and some are psychotic/negative, just as with the word *neurodivergence*, we have space for there being both positive and negative divergences.

The truth is that there are instances of psychosis which have yielded very negative results, where someone's mental illness includes what I call moral illness. However, most of us who've been psychotic simply try to lead a normal life and haven't killed anyone.

Statistically, around 3 percent of people will experience some form of psychosis in their lifetime.[2] That extrapolates to a lot of people, doesn't it? I'm not saying that psychosis is easy to deal with. It's not. When you're disconnected from reality, you may act strange. You may get angry at people who are experiencing reality differently than you. If you're like me, you'll usually act in a way you'll feel guilty about later.

It's important to note that just because it's embarrassing doesn't mean you're a terrible person. The stigma is terrible, though, so those winning against their illness typically don't speak up, and because not a lot of people speak up, the stigma remains. When people are stigmatized, they're less likely to get help because of shame, so more people stay sick.

When you're psychotic, you can wrongly and strongly believe someone is an enemy when they're not, and this can cause all sorts of issues. The times I lost my insight completely, I was thankfully in the safety of a psych ward. Most of the time, I've been convinced that *something* was going on, but there's always been an element of confusion and lack of total conviction to any one belief. With some

ability to "step back" intact, I would debunk one wrong belief only to have my mind present another. This isn't very pleasant, but it's better than being *totally* convinced of something that isn't real.

I'm not exactly sure what the difference is between someone like me and those who've committed monstrous acts like the ones we see in the media. I don't know where that sort of deviance comes from. That's a tough question, and I realize how complicated morality is. I'm weary of giving advice, so I can't tell you how to deal with someone who is psychotic. I will ask, though, that you consider psychosis to be a mental and not inherently a moral issue. When it comes to morality, I don't believe there are simply good and bad people. Morality is a spectrum, with all of us doing good and bad acts to varying degrees. When someone's decision-making skills are compromised by sickness, responsibility can be hard to define.

Some of the choices I would make after the centre in Three Sisters by self-medicating would make me even sicker, and these decisions were influenced by my illness. How much power I had to choose differently is up for debate; I believe that I did have some control and I take responsibility for misusing it. However, that misuse was fueled by apathy, which was connected to my depression. It's complicated. After I left, I started to be negatively affected by the deadening effects of the antipsychotic I was on. I needed to be on it, as I was still experiencing symptoms of madness, but the side effects were causing me to become depressed again. The depression made me apathetic, and the apathy made me care less about the decisions I was making.

I think dealing with the new label I'd found myself with was also hard to handle. I was mourning the loss of my outgoing self and coping with the stigma of having gone

"crazy." I'd identified as being a creative type, but now I'd discovered a lot of the world would see me as someone to avoid. I felt like an outcast, a failure. My problems got worse the more I accepted the negative labels. Crazy, psycho, nuts. These words are used to dismiss people, and I was dismissing myself. If you think you're a terrible person, it makes sense that you'd want to diminish that person, or you may feel like it's acceptable to self-harm. I saw myself as responsible for my mess. And although there *was* some responsibility due to my having the power to act differently, so much of my situation occurred due to variables out of my control. I did my best to push through, though, to solve my problems as best I could. Still, it was a struggle to see myself favourably.

Social activities were challenging. I began to struggle more with anxiety and started to isolate myself further. It wasn't long before I returned to cannabis and alcohol for help, forgetting how they had played a role in leading me to the hospital in the first place. I decided not to believe the doctors and didn't think self-medicating was *that* harmful. Unfortunately, it would be another slow decline. A year after my first hospitalization, I would be well on my way to visit again.

The Other Me

Pacing around in the basement, there I was, frantically broadcasting on social media what I thought to be crucial content. It was mostly nonsense or cryptic associations that I thought people would understand. Really, though, it only made sense to me. There were many posts a day, some with screenshots of the songs I was listening to with strange notes written on them. In some I had tagged famous people as I though we were conversing, and some were very dark and had a sort of digital violence to them.

Looking back, this embarrasses me. I would delete a lot of what I posted, but I wish I could go back to that point when I was experiencing mania and psychosis and just turn off my phone. I greatly worried my friends and family. It feels essential to do what you're doing though, and you're convinced of some grand scheme where it will soon be revealed that you're the story's hero. It's sad: if anything, you're often just alarming people or making them uneasy.

Let's say I never posted a thing. I wouldn't have posted the embarrassing stuff, but I wouldn't have posted the good snippets of my writing, which I'm told were helpful for people. Friends have said to me that what I posted was

interesting to them. We're often our harshest critics, so maybe I need to extend to myself the same non-judgmental nature I do to others. Still, knowing that there's a part of me capable of what seems like alien behaviour is uncomfortable. Who was that person? I'd like to be able to say he wasn't me. I suppose he's a part of me, my shadow, maybe that part of myself I can't accept and want to go away. The toxic psychotic part of me, toxic ego. The side of my neurodivergence that was detrimental on the neurodivergent coin. A sick me.

I've learned to reduce being that "other" me, that me who isolates himself from his community by his actions. That me who is riding some egotistical wave. I've learned to reduce him by making better decisions in the immediate to avoid the undesired ultimate. It's got to be one of the most foolish things to fail to see that the "other" person that I become, the parts of me I hate, are enhanced when I don't make better decisions to take care of myself in the present. Then, once I am this "other" person, I make more poor decisions in that present by posting nonsense that embarrasses me in the future. This embarrassment causes me to see myself negatively, which leads to decisions that promote further unwellness. I feel ashamed, so I self-medicate, which leads to me acting toxically. I then feel ashamed for acting toxically, so I self-medicate, which leads to me acting toxically.

At this point in my journey, it feels like I'm going around in circles. I get sick, so I need medication. The medication makes me depressed, so I self-medicate. Self-medication makes me sick, so I need medication. The medication makes me depressed, so I etc. I'm persevering the best I can, although it feels like I'm doing so without progress. I would visit the psych ward two more times, once a year for two years, before I'd be able to say I was starting to get the upper hand in the battle.

I'm Tired

It had been a couple years now since I'd been hospitalized, but that doesn't mean I wasn't still struggling. The delusions kept coming back, with or without the cannabis. It was hard to have hope that things would get better, but what choice did I have? Suicide wasn't an option. I wanted to do my best to avoid that sort of pain happening to my family. So I persevered and did my best to continue. Still, I was tired.

Sitting in the basement, my heart beating fast, I could hear what felt like mocking laughter from my family above. It was dinner time, but I wasn't with them because it hurt to be mocked by them. Or rather, when it *seemed like* they were mocking me.

It felt like it could become obvious at any time, but for now, it was all subtle things. I could tell by that smirk yesterday which coincided with that word, that they were referencing a mistake I'd made ten years before, laughing to themselves, *Oh what a loser John is.* Or so it seemed; these beliefs felt so true to life.

It seems ridiculous when I read this now, but these horrible moments of paranoia felt so real at the time. I feel them in my core, and at times I'm *almost* certain of

them. There's no creative wave to ride here. I'm crippled. Thankfully, I can use my critical thinking skills and step back to assess these things more soberly, but I'm just so tired of these sorts of thoughts popping up. These sorts of automatic beliefs that I'm despised and there's a plot to hurt me.

It's horrible, horrible when you feel as if the ground could fall from under you at any second. When the idea of a stable force of love and security is sabotaged by a paranoid mind. A source of comfort and strength like family is turned into a realm of enemies. Why is my perception so antagonizing?! It stops me from leaving the basement, it stops me from engaging with the community. It's so isolating. It's so exhausting. I just *feel* so tired. But, I must have *some* energy to keep going. Perhaps I'm stronger than I give myself credit for.

The laughter from upstairs continued but I no longer heard it as mockery. I took a pill to calm myself and it was working. I was flipping through some drawings when the phone rang. It was a New York number. I picked it up and heard my mom say with a sombre tone after brief small talk, "Grandpa died, and Auntie Bea isn't doing well."

The Missing Peace

Auntie Bea was a dear friend of the family. At this point in her life, she did her best to exist, but it seemed like it was a struggle. The care staff at her care centre would tell us that Bea tried to escape a few times but never quite made it. She was an impressive 100-year-old. What a collection of memories she would have had if she hadn't become so forgetful.

One of the staff opened the door to her room, and I walked in with my sister and our mother. We were in England for my grandfather's funeral and had time to visit Bea before going to the church where the funeral was held. We hadn't seen her in a while due to the ocean between us. One of the downsides of moving to Canada was that my mom lived far away from her dear friend. My mom went to put the kettle on to make us some tea. The water boiled with its bubbling sound, and soon the clear liquid became murky from the infusion of the tea bags. We sat and attempted small talk for a few minutes, but Bea struggled to understand what was happening. Gratefully, after a few reminders, Auntie Bea's face lit up as she recognized my mother's presence. My mom held her thin, wrinkled hands, which were shaking just like mine do from the lithium

medication. We shared a few smiles and heartfelt words on what would be our final earthly visit with Auntie Bea.

Over forty years earlier, previous visits between Bea and my mom were livelier. They'd talk about this, that, and each other's day. Share stories about the other people in their lives and current events with speed and precision. My mom was teaching music when they met, and when she left for Canada they stayed in touch for many years, sharing more stories over letters and making each other laugh from afar. We saw Bea a few times while growing up when we visited England, and she would always send birthday cards with British cash, never forgetting, not even once.

The significance and emotion of this moment in the old folks' home were too much for me to bear. I couldn't handle it and ran from the room in tears, to escape the intensity and sit on the well-tended British lawn to gather myself. My sister and mom came out a few minutes later, and we talked about Bea and how there was comfort in knowing she had lived an amazing life. I couldn't believe how stoic they were about the whole thing. Why did this chapter have to be a part of Bea's life? What a loss that was imminent, that had already occurred. Why does life work this way?

I didn't have much hope left. Cynically, I pondered, *This is what we're all in for, I suppose.* To lose our loved ones and then lose ourselves. We're considered lucky to live longer, but sometimes I wonder. I feel it's horrible to admit, but I do wonder.

I thought it could be me one day sitting in that old folks' home, wanting to escape where I'd ended up. It could be me who loses my mind again, and again, and again. I'd already gone mad many times. What sort of future do I have?

With this view I was burdened with, I'd lost sight of how much brilliant beauty there was. Scenes where we take

magnificent snapshots of worthwhile light. Where I've thanked the Higher Power for giving us existence. Where immediate struggle has led to an ultimate joy that was worthwhile. This joy was in me, patiently waiting to bloom again.

After some mindful breathing and counselling from my mom and sister, I was now well composed and feeling a bit less pessimistic, as a good vent can help us achieve. We carried on our way to my grandpa's funeral, seeing many family members sharing handshakes and hugs. It was a moving service. We shared stories after. My grandfather was an amazing man. He met my grandmother at art school and used to do the most beautiful watercolour drawings of churches and other buildings. A man of a *slightly* eccentric nature, he would put all his spare paint on one wall in their house, which was embarrassing for the kids, as all the different colours clashed. Or, there was the time that he accidentally put a cabbage in the mailbox and a letter in the fridge. So, maybe my absent-mindedness is hereditary! We laughed *with* him that day. Wherever his essence was, I'd like to think he was laughing too.

Bit by bit, people left the church. It was soon late in the afternoon, and I was looking forward to getting to bed. I was still pretty out of it, recovering from the happenings of the day and the long flight. It had been a chaotic trip across the ocean to get to England. I was very anxious about flying and had foolishly mixed benzos (anti-anxiety medication) with way too much red wine.

I blacked out on the plane and was lucky they didn't have to turn it around due to disorderly conduct. I'm told I behaved myself on the plane, but once we were at customs, I pushed through an officer who had just gotten off his shift. And then, once I left the airport, I puked in the car on the

way to where we were staying. My memory returned while lying on the floor at my aunt's and uncle's house.

Looking back, I'm embarassed by my behaviour. The person who did these things seems so foreign to me now. How selfish it is to be so self-destructive, when others care about you and have to endure the effects of your carelessness. I may have been sick and powerless to a certain extent, but it still hurts looking back knowing the pain I caused. I know now that I was a sick person acting monstrously, rather than simply being a monster. Nevertheless, my sickness had toxic effects and that's disconcerting no matter how or when I look at it.

When I was in England, I felt ashamed of what I'd become. The happenings I'd experienced directly and indirectly were paralyzing me from bettering myself. My self-esteem was very low, which made me unwilling to invest in my future. I felt like a villain, and although I thought it was terrible to be this villain, I didn't feel it was in my control to change. But was I really powerless?

A few weeks after my trip to England, I met with my doctor and told him about the trip. What he told me turned out to be an essential piece of the puzzle to work with. After relaying what I'd done, I told him that I thought he must think I was so ridiculous, so foolish, such a failure of a human being for getting so drunk. With an intense look, he looked up from his notepad and said, "John, you're sick, and you've *also* been trying to get better. You came here, didn't you?"

I realized from that doctor's appointment that I wasn't horrible. I was suffering from an illness, and it had hijacked my insight. Part of what was hijacked was a realistic view of myself. Yes, I was sick and powerless in some ways, but I *had* been taking steps to get better. Although parts of my mind were ill, and influenced my bad decisions, there *were* things

I'd been fighting. I'd tried around ten or fifteen different medications, among other body interventions. There were parts of me that didn't care because I thought I was a failure, but there were other parts of me that were acting in defiance of that.

It was possible to identify with being sick and therefore deserving compassion without identifying as an unchangeable agent, powerless. I might have contributed to my sickness *indirectly*, but there were so many things out of my control that led to my illness. Also, why is it so hard for me to show compassion to myself, to forgive myself for what I *had* done that contributed to my illness?

Forgiving ourselves is difficult. We often have voices of shame telling us that we're not good enough to be forgiven, that we're fundamentally flawed and undeserving. Suppose we can manage to forgive ourselves, though. In that case, we acknowledge the humanity of being agents who commit both wrongs and rights. Yes, I was, in a lot of ways, sick. I needed help. But I was by no means *all sick* and therefore without the ability to help myself. I had parts of me that were well, and those were the parts of me that I needed to capitalize on to help the rest of me. As the painter of the picture I have for myself, I had focused on what was wrong and not what was strong with my psyche. And these were lies of omission.

So, I was trying the best I could, even though my sickness was telling me that I wasn't. I was using the power I didn't think I had. I felt hopeless and that I wasn't worthy of wellness, but my perception was off. The battle just hadn't been won yet. Sure, it would likely never be a black-and-white victory. I was fighting an illness I'd have for the rest of my life. How well I could ever be was yet to be determined. I had control, but not complete control. After all, we can't write all of our story. My genetics, life events, social aspects,

etc.—these elements that were determined for me promoted apathy, which led to some bad choices.

In a way, it is a good thing that I made bad choices because it meant there were options I hadn't explored yet. There was room for improvement; this outcome wasn't the only outcome available. A popular definition of choice is the *freedom to choose differently*. That means I could have done something else. If I had the freedom to be wrong, I had the freedom to be *right* if I tried again. And I needed to keep trying. And I could. A few weeks after my doctor's appointment, I started to feel a bit better, a bit lighter. When I saw my doctor he gave me *another* med to try, and maybe this new medication I had started taking changed my brain, which was changing my mind.

With the new med kicking in, I lay in my room one night. I began thinking about how my grandpa was worried about me before he died and how I felt bad about that. I couldn't change that this happened. But, since I felt guilty for causing pain, perhaps I could do more to relieve the pain others were feeling because of me. To do this I would need to take better care of myself and feel worthwhile enough to do so. Yes, I needed to take care of myself to lessen the suffering of others. It can be selfless to take care of yourself. Oh, the irony! I'd been doing this to some extent, but I needed to do more to lessen the negative effect I was having on my community.

It may sound like I lacked empathy. But, in many ways, I had an abundance of it, which overwhelmed me to the point of being paralyzed by it. Also, I've been consumed by my struggles and my sickness. My sickness has affected others, but a lot of that sickness has been out of my control. Although, if I'm honest, there have been things I could have done better that weren't impossible,

just uncomfortable. This is a good thing. There's room for improvement!

When I saw Bea, I felt terrible for her, bad that life could go this way. *But doesn't that mean I thought there should be good?* Shouldn't I make whatever goodness I could, as I felt how bad the bad was?

Also, I was zoomed into the wrong part. The chapter at the end of Bea's life didn't reflect her whole story, just like my sickness didn't fully represent mine. Bea had her earthly journey, but I still had the time to use my choices to lessen the suffering in this world. My suffering and thus others' suffering. I had time to add positivity to my story; by doing that, I could lessen other people's pain, like my parents'. Some of the compassion I felt for Bea needed to be in some ways redirected to myself. I'd be willing to bet that's what Bea and my grandpa would have wanted.

Yes. I needed to heal myself to lessen others' pain. I'll do what I can and not shame myself for doing more than possible. I couldn't alleviate the pain my grandpa felt because of me, and beating myself up about this was counterproductive. I was sick, after all. But I could keep trying to lessen other instances of that pain by improving my efforts to get well. They say you have to get well for yourself. But a big part of what helped me care more was recognizing how much people I loved were suffering because I wasn't loving myself. I felt worthless and disposable, so I wasn't caring for myself. But my family thought I was worthwhile. *I needed to trust that they were right and that I was lovable.*

Yes. I had been fighting, but there's more I can do. I'll start going for walks, I'll start meditating, I'll get sober. I will be relentless. Wait, I have been relentless.

This is my *continued* purpose. To get myself well to promote others' wellness. I'd want to help more and more if it were a loved one of mine who was sick. Why not do that for me? Shame, that's why. I thought I was a monster. Well, damn it all to hell.

Reconstructing with a New Peace

Enduring the Ups and Downs

With my curiosity growing, I asked myself, *How am I making myself?* Here I was every day, making choices that changed and reinforced my identity. I hold concepts which are so disconnected from the material. However, it's the material that generates my concepts! The light turned green, so I directed myself forward out of the deep thinking; it was time to focus on driving again. The street I was on approached a traffic circle, and I was reminded of the time in England when the traffic was so bad that we had to keep going round and round and round.

My trip to England was now a few years ago, and I had been progressing. Still, life continued to be a struggle. I'd managed to avoid hospitalization, which I was proud of. However, I had recently heard some horrible news. The news that Avery from that oh-so-formative band of ours had passed away. And although I hadn't seen him in a while, it shook me deeply that he wasn't on the earth anymore. I didn't know how to feel when he passed. Was I allowed to mourn as if we were always close? There were all sorts of emotions and distorted thinking to reckon with.

I did, though, find comfort in going for runs and hearing him encourage me with that calm confidence I admired him

for. He's in my dreams from time to time. I know now that the importance of some relationships transcends the amount of time we spend in them. This loss changed me, but I wasn't going to be devastated by it. Thankfully, I was in a better place than when Antonio died. I had resiliency. So, when I "needed to go on a long road trip," I didn't run out of gas.

And so there were forward and backward movements, toward and away from wellness. After my trip across the ocean, I had a newfound acceptance that it was worth it to love myself because others loved me. I was eager to help myself, so I quit weed and alcohol *again*. Unfortunately though, my depression would hit me with such a force that I started self-medicating again.

I was exercising regularly until I got sick with paranoia and didn't want to leave the house. That was a challenging phase, but I endured it, didn't I? I was doing OK but surviving more than thriving. Still, I *had* made progress. I was completely sober for a year until those depressive symptoms started getting the better of me *again*. I'd learn therapy techniques, which helped significantly reduce the severity of my delusions. It certainly hasn't felt like it's been the most efficient journey, but I *have* travelled closer to wellness even though some days it hasn't felt like it.

I was battling as best I could, but my chronic illness kept fighting me with relentless strength. The medication that had helped me achieve the England breakthrough was now causing panic attacks, so I recently switched it for something else. Fingers crossed, this change makes a positive difference that's more sustainable. It's incredible to me how I can be so eager and full of overflowing hope one day and so down and depressed on another. These sorts of ups and downs come with precious times of balance.

The England breakthrough didn't trigger a completely upward trajectory, unfortunately, because that's not how recovery works. Recovery, with its twists and turns, has been a rollercoaster of being willing to make changes to better myself, and with moods and news so poor, apathy has led me to self-medicate and avoid healthy activities.

Still, I may not have been cured after England, but I've made important steps that would help carry me forward, backward a bit, further more, backward a lot, further a bit, etc. And sometimes, what seems like a little step forward turns out to snowball into something truly big.

I exited the traffic circle and found my way to my art studio. There, I worked on my résumé as well as a cover letter. I was applying for an opportunity my friend had told me about. The Canadian Mental Health Association was training people to become peer support workers. I had my issues, but I felt well enough to give peer support a try. Little did I realize how much further into wellness I could be.

Power Acceptance

I felt the buzz in my front pocket. My phone was ringing. I pulled it out and put it to my ear.

"Hello?" It was good news this time: I had been accepted into peer support school!

Getting that call was exciting. I was going to train as a peer support worker! I wasn't sure what that meant exactly, but I was looking forward to finding out. I was oblivious to how much it would change my life. Soon, I'd connect with peers who'd struggled as well, and I'd learn how beneficial and constructive my voice was. I'd ditch a lot of the stigma thrown at me. I'd be rid of a lot of the stigma I held against myself.

And so a month or so after I got the acceptance call, I went up an old elevator, feeling a bit nervous about meeting my fellow peers. I walked into a room on the tenth floor of the building we were training at and saw people sitting in a circle. Some were talking, and most seemed nervous like I was. I'd soon find out there were many things they did or had gone through that I could relate to. Here are a few of the things that I learned.

Sitting in that circle, we were all equals. There was no head of the table, so to speak. No doctor looming above. The power dynamic was one of equality. We had a peer mentor facilitating the conversation, but she was learning, too. It was a collaborative exercise. Each of us had lived experience with mental illness, which is where our expertise was.

This concept of sharing lived experience is an integral part of peer support. We've all heard it before, so this might sound trivial, but meeting someone else who has been in your shoes can be life-changing. It can teach you things. So often, with mental health, our stories are left untold. This is because of the shame associated with being mentally ill. So, being in a room with others like me who were willing to share their story was a very powerful experience.

The isolation that can come along with being mentally ill is horrible. Not a lot of people want to talk about things like psychosis / altered states *yet*, so it was refreshing being in that room and being able to be open with what I'd gone through. When we see what's possible for someone else who's like us, we realize what could be possible for us. Our self-determination facilitates these possibilities.

One of the other tenets of peer support is self-determination. I would wrestle with this with the other peers, and after a while I had to admit that I *did* have the power to improve my situation. There were ways that I *had* been using it and ways that I could improve how I'd been using it. It can be painful to admit that you have the power because it means you're responsible now and were responsible in past situations. Yes, a lot of the time, if not all of the time, our choice is influenced by outside factors. But we do always have *some* control. To quote Viktor E. Frankl, "Between stimulus and response, there is a space. In that

space is our power to choose our response. In our response lies our growth and our freedom."[3]

It can be pretty complicated though. Suppose someone experiences trauma and becomes mentally ill. In that case, we don't want to blame them for becoming sick, *but* we also don't want to limit their freedom to get better, to improve their situation. It can be reasonable that people get stuck and don't utilize their power well, but that doesn't mean there isn't the possibility for furthering wellness. I don't mean to say that we can simply cure our mental illnesses by doing the right thing. Recovery is going to look different for everyone, and sometimes we do everything we can and are still very sick.

As to what's possible, only the person suffering knows what sort of wellness-improving behaviour is possible, impossible, or simply uncomfortable. Sometimes, though, there's strength we're not aware we have. Peer support can help us find that strength inside ourselves. To help us realize our power to dream and then move towards those dreams.

A certain vulnerability comes with dreaming. In caring, setting a goal, and aspiring. When we say we want/value something, we open ourselves to there being a loss. On the flip side, we're provided a direction for growth, a light to move towards. However, once we declare there is a light, we open up the possibility of losing it or of that light going out. Thankfully, even if that light does go out eventually, it's often the process of chasing our goals, our lights, that creates value for us. Or, some new light is found while we're aspiring.

We can accomplish a lot if we put our minds to it, and a lot too as a byproduct of what we're aiming for. But some things are so painful that we must do other things before we can lift the weight of the first thing. And so

it's counterproductive for an outsider to say, "Just do an activity," when we're unable to. We know ourselves best, so we must be honest with ourselves about what moves are realistic. Also, we should allow ourselves forgiveness for when we didn't use our power or couldn't do what we wanted. It is a hard struggle, after all. Mental illness is a battle using broken weapons to mend themselves.

Yes, I needed to *continue* to transform myself. And to transform myself, I had to use myself. It's the paradox of using one's own mind, which may be impaired due to mental illness, to address and heal that same illness. The good news is that just because I am broken in some ways doesn't mean I'm broken in all of them. Consider this example. I might think that *I need to meditate to feel better, though I need to feel better to be able to meditate.* Isn't this an issue of power? How much power do I have when I'm mentally ill? How much choice is there to choose where my journey goes next?

I may lack the motivation to do something, but that doesn't mean the power isn't there. It may be uncomfortable to act without motivation, but it's possible. If I really can't meditate, I can still focus on what I *can* do. Maybe that will help create some momentum so I can eventually meditate. Perhaps I'm telling myself that I'm not the kind of person who meditates and that I need to change that narrative. I've identified with being lazy, and lo and behold, I've felt justified in being inactive.

We may need help to change our story independently. It may require outside influence. Sometimes, this can happen from receiving positive encouragement from someone we *trust.* Or maybe it's a matter of finding the proper medication to spur future improvements. What you're able to do is up to you to decide, but we all have *some* amount of choice,

of freedom. When we subscribe to labels, we can limit our freedom. In a way, it can be dangerous to label ourselves as mentally ill because it implies that we're defective in some way. But aren't we? Isn't who we are not working? There may be parts of us that need fixing, but to take a label like *mentally ill* and make it all-encompassing can be smothering and blunt. We're also neurodivergent, with the same brain that is ill having positive aspects too. Aspects that often include abilities that go beyond a normal brain, that don't need fixing and can help us repair the negative aspects.

The term *neurodivergent* is excellent because it sees our uniqueness and recognizes that the diversity of our minds is a *good* thing too. We're not fully flawed. And sometimes it's society that needs to do the changing. Our differences make us stronger and strengthen society. We should recognize that and nurture these skills. I imagine we'd see a lot less mental illness if we did.

At peer school, I started to productively work through ideas I'd been struggling with. I learned about words like *self-determination* and *self-talk*. I had the space for my thoughts to become words and thoughts again. Reconstruction happened. The language we use surrounding mental illness matters; it guides our narratives for better or for worse. For me, part of that guiding came from having more pride in myself. When I'm sick, I have less pride in myself. When I'm a healthy amount of proud, it's easier to enact self-care. Investing in myself is easier because I believe I'm worth it. Some parts of me, after all, aren't sick and don't need changing. Those parts deserve further wellness.

We may have large parts of us that would be better if they were changed. We may be mentally sick in a lot of ways. But, no matter how ill we think we are, everyone has their unique blend of power to improve their situation. While

mental illness may be a part of our story, it's never the whole story.

And so one day, I walked to my car after a peer support training session. I found myself smiling, thinking about all that I'd gone through in the past ten years. I'd prefer a lot of it hadn't happened. But now that it had (the past is cemented), I could share my story with others as a way to help those who are *now* where I was *then*. And the beauty of this is that by giving back, I myself would become more well.

Lens Implications

It was my first day of elementary school and I was playing with smooth wooden blocks and constructing abstract buildings in free form. This is a fancy way of saying I was stacking things. While I was doing that, I watched the teacher lean down to ask another student, "What colour is this?," pointing to a dinosaur that was printed and laminated to protect the paper when it was handled.

I don't remember what colour the boy said it was, but it wasn't the colour this dinosaur was typically called. The teacher then told the boy that he was colour-blind. She tried to explain it tactfully, but his reaction was immediate and intense; he burst into tears. It was clear that he felt somehow flawed, and this revelation was a painful blow. I'm assuming she didn't mention that certain colour blindness can give a person better night vision or that colour-blind people can better spot camouflaged objects or detect subtle variations in texture in a way that exceeds regular sight.

These would have been good things for her to know, although we can't expect our teachers to know everything. Maybe this is something she could have talked to the parents about first, done some research before telling the

child he was colour-blind—*unless* this was something the parents wanted to handle themselves.

This all makes me think about when I heard that I had a psychotic disorder. A *much* more severe ailment, yes, but similar in that the label sets someone apart from the norm. As I've mentioned, there are positive aspects to being colour-blind. Are there positive aspects to having psychosis? My psychosis has included me being wrong while being sure that I was right. In itself, there isn't anything good about being wrong, but being wrong could serve as a stepping stone to an eventual right though, couldn't it? Also, aren't there areas of life, like spirituality, that are hard to prove right or wrong with any certainty? I believe that there are positive aspects to my condition, such as my aptitude for spiritual experiences. Or, at the very least, aspects that are separate from psychosis but wouldn't exist without the potential for psychosis to exist, too.

There's the unconventional thinking that accompanies psychosis, as well as the openness that's hijacked by psychosis; both can help us with our creativity. You could also argue that unconventional thinking is *a part* of creativity. As I've hinted at, there's also the mystical or spiritual perspective that can be coupled with psychosis, or, again, *is psychosis*. Finally, there's the personal growth and resiliency that come from going through the hardship of psychosis, a benefit not unique to psychosis but one we can apply to all struggles in life.

Psychosis also shows me how misleading perception can be and that although something may feel like a certainty when I'm up close to it, when I step back and incorporate other sources into my assessment, I can see how wrong certain beliefs are. The fact that my truth isn't always *the* truth is humbling. Though there is nothing humble about a

delusion of grandeur (psychosis), it can serve to be a negative means to a positive end. Psychosis is a disconnection from reality, and well, some disconnections from reality are *good* and even serve as examples of where reality might go to.

Psychosis, as a word, does not point to a positive thing. Do we abandon the word *psychosis* and use a different word? Or do we work to change the perceptions of it? If, instead of using the word *psychosis* when I first got ill, the doctor included in the conversation that I was neurodivergent or that I experienced altered states, I would have felt more positively about my situation, and that would have *directed* me differently. Calling psychosis an altered state would help lessen the stigma of having these experiences. When there's less stigma, people are more willing to better themselves. Why would someone put effort into themself if they believed they were a monster?

The word *psychosis* is, unfortunately, very close to the slur *psychopathy*, but they're very different. As someone who deals with psychosis / altered states, I, if anything, have abundant emotional empathy. Thankfully, it's possible to change our perception of the word *psychosis*, so maybe keeping it is a good option. Now that I know that the word points to a variety of phenomena that are more nuanced than commonly understood, I'm more compassionate towards others who experience it and towards myself as I experience it, too. This doesn't mean that more than often, psychotic breaks aren't *a lot* to handle for everyone involved.

The boy now knew he had flaws in his vision, yes, and there was a real loss there, just like there's a loss when you learn you have a psychotic disorder, which has *very* detrimental factors. I don't mean to sugarcoat it. But he could *also* learn that he surpasses his peers in some ways

because of it. Yes, being set apart can be painful. Still, we can counter that pain with notions of being set apart and *excelling.*

What should the boy do now that he knows he's different, that there's something wrong with him? Thankfully, there isn't a lot of stigma against the colour-blind. Perhaps the older him will realize it wasn't as dire a situation as he thought. My psychotic disorder is different in that there is a lot of stigma surrounding it, and fear too. Although it is a big thing to handle, it's not a death sentence. Thankfully, it can be medicated and managed, with some folks losing their delusional symptoms entirely or mostly.

It's an unfortunate truth that 30 percent of schizophrenics don't respond to antipsychotic treatment, so recovery is going to look different for everyone. Still, you don't know what you can do until you try. These are chronic illnesses, and some people have some horrible versions of them. I do believe, though, that everyone has the power to improve their situation in *some* way.

For me and many others, antipsychotic drugs help to significantly reduce delusions. The ones that remain for me are mild and can be managed with cognitive behavioural therapy techniques. If you're interested in learning more about CBT for psychosis, there are a lot of resources out there. I'd recommend the book *Think You're Crazy? Think Again* by Anthony P. Morrison et al.[4]

If you struggle with psychosis, I hope things get better for you. I'm at a place in my life where I'm at peace with my lot in life and have come to terms with the fact that I have to deal with this condition in some way or another for the rest of my life. My disorder and/or neurodivergence have several directions that they pull me in, but at this point in my life I don't think I would get rid of them. I say I'd

keep them because of the good things I would inevitably lose without them, which are *connected* to the bad. My creativity and my wisdom are mine because of and despite my illness. The *despite* is, in a way, also a *because*. The reaction requires what's being reacted to. When someone tells you that you can't do something, it can sometimes motivate you to do it more than it would if they didn't say anything.

What makes me consider choosing not to have my neurodiversity is the conflict and suffering it has caused my family. But this hypothetical choice to change myself is a fictional exercise. I was born this way, and that's that. In a way, it was all of our destinies to have had this to deal with. Would my family remove my special traits to eliminate the awful ones? You'd have to ask them.

Another thing to consider is that the awful parts of my illness have given me something to overcome. Through overcoming, I've achieved heights greater than I would have if I hadn't had the problem in the first place. Problems which would exist whether I overcame them or not.

There's also the issue of how we view our own character. How we see ourselves can be skewed or influenced by unrealistically negative judgments. Remember that if I see myself unfavourably, I might feel like it's acceptable to act unfavourably. When I've felt like an outcast, I haven't been as invested in society, and when I'm not invested in society, I pull further away from it. The stories I tell myself about myself can fuel negative or positive behaviour. We are always making and being made by ourselves. The story we write, writes us.

I pulled my hands away from the keyboard and closed my laptop. I was tempted to resolve things further, but I decided that I should sleep on it, and also unsure if it could be put any simpler.

With a resolved intensity, I stared intently into the mirror on the wall by my desk, thinking about what I'd written so far and wondering what to write next. I felt eerily content. Everything seemed to be in its proper place.

I closed my eyes and focused on my breath, feeling it connect my mind and body. The air swung like a pendulum. In through the nose, then sensed by the top of my mouth, close to my brain. And then the shift. Out through the mouth, done so for twice as long. And then I started the cycle again. After a few minutes of this, I opened my eyes and gave a thumbs-up to my reflection. I got up from my chair, walked over to my bed, and lay down. After a few minutes of mind wandering, I approached the edge before sleep. And then my perspective, my consciousness—it disappeared.

Lose One, and You'll Lose the Other

After a refreshing rest, I lay there in bed, eager to return to writing. I pushed the blankets off me, swung my feet onto the floor, and put some clothes on. I then found myself staring out the window at a dynamic sky, its canvas filled with distinctive clouds and morning colour. My mind, like a deeply receptive camera, soaked in the sights, a nontoxic view.

The earth was on its journey, as it's done so many times, enacting its circular routine with admirable perseverance. A previous me might have seen it as monotonous. Still, with today's perspective, I felt optimistic and saw this repetition as a worthwhile ritual. *We may be going around in circles*, I thought, *but we are at home in doing so.* I rubbed my eyes, grabbed my laptop, and headed downstairs toward the kitchen.

It had been a year since I tried a new medication and did my peer support training, but I still couldn't get over what a strange feeling it was to wake up this early and have it be the happiest time of the day. Before, every single day, it was *painful* to get moving. And although I'm happier, I'm not manic. I'm sleeping well and not disconnecting myself from those I care about. When I'm sick, I'm unnaturally up

or unnaturally down. Now, or at the very least, *for now*, I was balanced.

It's taken me a while to get here, but this past year has been full of growth. I set my sights on a better life and have been working towards it—bit by bit, view by view. Like when I was delusional, the total resolution is ever elusive. However, unlike delusion, there's satisfaction with every piece of the puzzle I find. It's been a privilege to have had the time to overcome so much. I'm hoping for many more years to do this, as there's much more work to be done.

I smiled and poured myself a cup of coffee. I put the pot down and thought about what the title for my writing would be. I had *Reconstruction Quest*, which I felt was appropriate. Now I had to figure out which experiences are relevant and which stories have useful weight. The ones I still remembered would have proven their relevance. They must be important to some part of me. I don't recall choosing to keep any of them, or maybe I did by continuing to return to them. I used to get overwhelmed by some memories, but I'm much more stable now. Better like when I was at Gerry's late at night with friends after a show, slurping eggs and cracking jokes.

Well, this is an upgrade. I'm more productive than I was. I'm a better communicator with a stronger work ethic. I'm wiser and less reckless. There are other ways, too, like how I've become mentally stronger because of what I've gone through. I recognize that I'm neurodiverse, which means there are parts of me to be proud of, as well as parts of me that have been challenging.

I've lost parts of myself that I used to enjoy, such as some of my sociality, and have minor episodes from time to time that are stress-induced. I'm hopeful that as I continue to work on myself, the minor episodes will continue to decrease, and

I'll regain some of those parts of my identity I miss. I have bad days and backward steps, but they don't define me. If I zoom out, I can see these counterproductive steps become diluted and less definitive of me as a whole. I am improving my journey, even though it doesn't feel like it. Also, I remind myself that these backwards steps, although to be avoided, are part of what it means to be a dynamic human being. And in this messy mix, lately it's been so lovely to be able to be grateful and to be able to say that my life is more good than bad.

I still deal with suffering, a lot in small doses, as preventative measures. And then there's the suffering which I know exists out of frame, some of which will inevitably travel from my future to my present. I refuse to let its existence paralyze me from doing anything about it though. I can't change some things, but I can prepare myself for a lot by strengthening my resilience. Or there are steps I can take to minimize what I have to endure. I know they're not here in physical form anymore, but I want to do well for all my friends who have passed away. It's terrible that they're gone, making me think it's good to be here. It's good to be here when working towards a purpose, so I should do my best to make choices that fulfill my purpose.

I'm happiest when my family is happy. So, serving the community as a purpose feels like a good one. This sort of belonging could be seen as something that would decrease my freedom, but if anything, I feel freer having a foundation to work from. I'm responsible to this foundation. We're connected. I realize that if I suffer, others suffer, in varying degrees. It depends on the relationship as to the magnitude of the effect. The relationship between a parent and a child? How could they not suffer when you do? Theirs is the most extraordinary empathy ... or maybe the Higher Power's is?

If The Higher Power's love is greater than a parent's, we are due to be well indeed.

In a way that's not religious, we have faith that when we start a new habit, the habit will be worthwhile. We have faith that life is worth it when we invest in it. I can't fully explain why we should suspend our doubts about spirituality. Like being invested in life, it's a leap we choose or choose not to take. At this point in my life I have faith that life makes sense from a greater view, that I'm a part of something bigger, some grander love.

There's this great and terrible vulnerability with love. With it, we extend what we care about beyond ourselves, so when what we've been extended into is in pain, we feel pain as well. The greatness is in the reality that when we extend ourselves to someone else, and they feel joy, we feel a joy that is one of the most incredible types of joy you can feel. And so here we are in a world that has these two vulnerabilities. Lose one, and you'll lose the other.

Free will offers us the potential to make choices that decrease overall suffering, or increase it. Sometimes, it's obvious what choices lead to the most suffering, and sometimes not. We can make choices to suffer in small ways, in the immediate, leading us to an ultimate goodness, or we can have some goodness now, which may unfortunately lead to greater suffering. Lose the possibility of bad choices, and you'll lose the possibility of good choices—like choosing love. Can you imagine love without choice? On a less abstract and more concrete note, there are ways we can choose to increase the love we have for ourselves and others.

I like to think of mental health solutions as either "top-down" or "bottom-up." We can intervene in the body (bottom-up), change things like meds, diet, exercise, etc., or intervene in the mind (top-down) and change how we see

ourselves or learn to reframe thoughts/beliefs, etc. For my recovery, it's been important that I utilize both approaches, with one change facilitating another. What do you start with? Whichever one you'll actually *do*. There are so many things in life we can't do. But what *can* you do?

I can reconstruct my journey as a way to process and learn. It will be a quest to reframe my quest to get this far. Highly self-indulgent, sure, but changing the world for the better starts by changing yourself. To change yourself, you need to face yourself. There's the mirror. Yes, here we are at the threshold. I will start writing the book now.

Notes

1. *risk for psychosis* (p. 14) Louise Arsenault et al., "Cannabis Use in Adolescence and Risk for Adult Psychosis: Longitudinal Prospective Study," *BMJ*, vol. 325, 2002, 1212, https://doi.org/10.1136/bmj.325.7374.1212.

2. *psychosis in their lifetime* (p. 86) "Psychosis & Psychotic Disorder Statistics," *The Recovery Village*, 11 June 2023, https://www.therecoveryvillage.com/mental-health/psychosis/psychosis-statistics/.

3. *our growth and our freedom* (pp. 110–111) Viktor E. Frankl, *Man's Search for Meaning*. Beacon Press, 2006.

4. *by Anthony P. Morrison et al.* (p. 118) Anthony P. Morrison et al., *Think You're Crazy? Think Again: A Resource Book for Cognitive Therapy for Psychosis*. Routledge, 2008.

Photo at Workshop Studios by Emma Palm

About the Author

John F. Gerrard is a multidisciplinary artist, with a focus on visual art. In his teens and 20s he was active creatively as a musician, touring across North America and playing locally. During this time he started doing visual art, mostly graphic design work for bands and small businesses. Gerrard attended the Alberta College of Art + Design (now Alberta University of the Arts) with the intention of pursuing a design degree, but became obsessed with creating with charcoal and paint. He majored in drawing at ACAD and then went to work at a commercial sign company. In 2016 he left to pursue art full-time.

In 2018 Gerrard was trained by the Canadian Mental Health Association as a peer support worker. Since then he's been developing his art practice with mental health advocacy work. A highlight for Gerrard has been working with Branch Out Neurological Foundation, making images based on interactions with neuroscientists, taking part in their charity events for three years in a row.

In 2019 he had his first international show in Chicago as a part of the "SOME PEOPLE" (Every)Body exhibition. This multidisciplinary project examines the ethics, people, processes, and systems that constitute the maintenance of, and barriers to, health for human beings.

IF YOU LOVED THE BOOK
AND WOULD LIKE TO SHOW YOUR
SUPPORT, SCAN THE QR CODE
ABOVE TO WRITE A REVIEW.

SCAN THE QR CODE ABOVE
TO CHECK OUT MY ART AND
OTHER BOOKS.

Manufactured by Amazon.ca
Acheson, AB

14078182R00088